Haunted Tampa
Spirits of the Bay

Deborah Frethem

Published by Haunted America
A Division of The History Press
Charleston, SC 29403
www.historypress.net

Copyright © 2013 by Deborah Frethem
All rights reserved

First published 2013

Manufactured in the United States

ISBN 978.1.62619.213.3

Library of Congress CIP data applied for.

Notice: The information in this book is true and complete to the best of our knowledge. It is offered without guarantee on the part of the author or The History Press. The author and The History Press disclaim all liability in connection with the use of this book.

All rights reserved. No part of this book may be reproduced or transmitted in any form whatsoever without prior written permission from the publisher except in the case of brief quotations embodied in critical articles and reviews.

*For Signe, the light of my life.
And for Craig, now and forever.*

CONTENTS

Acknowledgements 7
Introduction: A City Built on Bones 9

Part I: Early Days
Fort Brooke 11
The Fort Brooke Parking Garage 13
The Legend of Jose Gaspar 14

Part II: The Old City Cemetery
Oaklawn Cemetery 17
Dr. John P. Wall 18
Vincent Martinez de Ybor 19
Charles Owen 20
Mayor Lancaster 20
Darwin Branch Givens 21
William and Nancy Ashley 22
St. Paul's AME Church 24

Part III: Downtown
The Hotel Floridan 27
The Tampa Theatre 34
Duckweed Urban Market 43
The "Five and Dime" Block 45
The Old Federal Courthouse 48

Contents

The Tampa Police Memorial	53
The Mad Russian	56
Old City Hall and a Clock Named Hortense	60
The Old Tampa Book Company	64
The Sykes Building	66
The Scrub and the Jackson House	67

Part IV: Across the River

The Falk Theatre	69
Plant Hall	73

Part V: Around the Bay

The Sunshine Skyway Bridge	81
The Ringling Ghosts	85
Howard W. Blake High School	89
The Grey Lady	90
The Sulphur Springs Water Tower	91
Selected Bibliography	93
About the Author	95

Acknowledgements

Sincere thanks to the staff of the Tampa Theatre, especially Jill Witecki, John Bell and former staff member Tara Schroeder; to all the many students and former students of the University of Tampa who have shared their stories with me over the years; to the Tampa History Center Research Library, especially David and Phyllis; to Paul Guzzo, for his information and inspiration regarding Charlie Wall; to Michelle, Derek, Jensen and Forest of Duckweed Urban Market; to the staff of the Hotel Floridan, especially April, Daniel, Costa and, of course, Tony at the piano; to Lynn Brown, for believing in me; to Donna and Steve Bremer, who first helped me to become a writer; to Tim Reeser, for allowing me to tell ghost stories on the streets of Tampa; and most of all to Craig, for photographic and technical support, holding my hand or kicking my rear as needed.

Introduction
A City Built on Bones

The Spanish conquerors called the bay *Bahia de Espiritu Sancto,* or the "Bay of the Holy Spirit." It is said that history is written by the winners, but in this case, it was the ancient name of the bay that survived, long after the Spanish name was forgotten. The Calusa, a native tribe from the southern part of what is now Florida, called the bay "Tampa." In their language, the word means "sticks of fire" or "place of lighted sticks," most likely a reference to the thousands of lightning strikes that hit the area every year.

Before the arrival of the Spanish in the sixteenth century, the Florida peninsula was home to several different Native American tribes. One ancient tribe had villages along what we now call the Hillsborough River, at the spot where that river meets Tampa Bay. This was the Tocobaga tribe. Some archaeologists believe that they were here for as long as ten thousand years before the arrival of the Spanish. A peaceful people, they had only rudimentary agriculture and ate primarily shellfish. During the years they lived around the bay, they would take the shells from those oysters, scallops and clams and pile them in central locations, creating huge shell mounds, some over fifty feet high. They used these mounds for many things, often building temples and homes for the chiefs at the apex. But the most important use for these mounds was as burial sites. When a member of the tribe passed away, the body would be carefully and lovingly laid out on a platform of palmetto fronds. The mourners would then wait for the elements and bugs, birds and rats to do their work. When the bones were picked clean, they were wrapped in ceremonial clothes and buried within the shells. At one time,

Introduction

such burial mounds existed all around Tampa Bay. A mound over fifty feet high and two city blocks long stood in what is now downtown Tampa's Lykes Gaslight Park, south of Franklin between Madison and Kennedy Avenues. The population of the Tocobaga was decimated by the diseases brought by the Spanish Conquistadors. Today, the tribe is believed to be extinct.

In the early 1700s, another band of Native Americans came to the area. They were renegade Creeks from farther north. The Spaniards called them the "Cimaronnes," meaning "wild ones." Today, we know them as the Seminoles. When they came to the area, they respected the cultures that had preceded them. So they left the shell mounds undisturbed.

In the early 1800s, when the first European American settlers arrived looking for a permanent home, the shell mounds still stood proud and tall. But those roads in early Tampa were made of dirt, and when the summer rains came, the roads became impassable mud. The shell mound seemed like a convenient "fill" to make it easier for horses, mules and oxen and the carts they pulled to pass through the streets. The mounds were torn down, bones and all, and scattered into the mud. And the bones still lie on those early streets. Over the years, the bones were covered with cobblestones. Eventually, those roads were paved over to make the streets we have today. Thus, it is no wonder that Tampa is a haunted city. It is, quite literally, a city built on bones.

Along the shores of the Hillsborough River, in front of the University of Tampa's Plant Hall, stands a steel sculpture that shimmers in the sunlight. Done by sculptor O.B. Shaffer, it appears very modern, but its upward-reaching bands are there to represent the name given by the Calusa so long ago: Tampa, sticks of fire!

PART I

EARLY DAYS

FORT BROOKE

For about one hundred years, the Seminoles lived peacefully in Florida, but by the early nineteenth century, the "white man" had set his sights on their sunny peninsula. Florida became a territory of the United States in 1822. The ink was barely dry on the treaty with Spain when the United States decided to establish a military presence near the mouth of the Hillsborough River. On January 10, 1824, Colonel George Mercer Brooke and four companies of the Fourth U.S. Infantry arrived at the selected site. A wooden fort was constructed from local materials. Originally called Cantonment Brooke, it became Fort Brooke later that same year.

Among the soldiers stationed at Fort Brooke was a young officer and graduate of West Point named George A. McCall. While serving in Florida, he wrote many letters home to his family. These letters were preserved and later gathered together and published under the title *Letters from the Frontier*. In a letter to his father, dated March 28, 1824, George recounts what may be Tampa's earliest recorded ghost story.

At about 9:30 on a foggy morning, one of the sentinels, who had climbed to the top of a huge live oak for a sweeping view of all of Tampa Bay, suddenly called out, "Sail ho!" Officers and men, some carrying telescopes, hurried to the shore and saw sails on the horizon. Was it four ships or five? It was hard to tell at a distance. But as the ships continued to come nearer

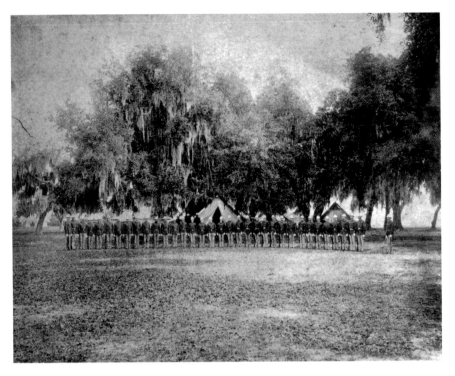

Troops assembled at Fort Brooke. *Courtesy of the Tampa-Hillsborough Public Library System.*

and nearer, they could clearly discern the sails of five ships. Uncertain as to just who might be in these ships, Colonel Brooke decided to go out and meet them and ordered refreshments to be prepared to welcome their guests, whoever they may be. But as the commander and several other soldiers were getting into a small boat to row out to meet the ships, one of the soldiers cried out, "Where, where are the vessels?"

The five ships had completely disappeared. According to McCall, "Men rubbed their eyes and could not yet believe them."

There has never been an explanation for the phantom ships that vanished from Tampa Bay that spring. But there were many at the time who remembered that a ship's crew had recently been murdered by pirates in that spot. Were these ships sailed by the ghosts of that murdered crew? No answer has ever been found.

Early Days

The Fort Brooke Parking Garage

Fort Brooke remained an important outpost for many years. Throughout the Seminole Wars, it served as a launching point for troops and as a supply depot. During the Civil War, it was captured by Union forces on May 6, 1864. But as the war ended and the years passed, the government decided that the old fort had outlived its usefulness. The fort was decommissioned by the U.S. Army in 1883. The buildings were simply abandoned and allowed to deteriorate. In time, the area where the fort once stood became the "sin district" of Tampa. In the waning days of the nineteenth century, other structures were built over the old foundations. Fort Brooke had become just a part of history.

However, in 1980, the city began construction of a municipal parking garage. It was to be a large structure near the intersection of Franklin and Whiting Streets. Unfortunately, when they begin to dig foundations, they made a grisly discovery. It seems that when Fort Brooke was abandoned in 1883, no one had bothered to do anything about the Fort Brooke Cemetery. Bear in mind that the bodies in that graveyard were not embalmed. Many did not have coffins, and the few that did had coffins made of wood. Not every grave had a marker, and the few that did were marked with wood, not stone. In most cases, over a century had passed since the original interment. Decay and decomposition had taken their toll. What was left was little more than bones.

Still, there were some clues to the identity of the remains. Metal buttons and scraps of wool clinging to skeletons suggested that some of the dead were soldiers, who wore heavy wool uniforms, even in the Florida heat. Wooden buttons and cotton cloth suggested settlers. A few scattered beads even suggested that the bodies of Seminoles were buried there. Further excavations even revealed a few bones that were dated back almost two thousand years—undoubtedly the remains of the Tocobaga who once lived in this spot.

Of course, this was the cause of some concern among historians and archaeologists, but progress will not be stopped. The bones were removed, and construction continued. The bones that were deemed to be from settlers and soldiers were moved to a mass burial site in Oaklawn Cemetery on the outskirts of downtown. The bones of the Seminoles were given to the Florida Seminole Tribe and were buried on tribal land, out near the Seminole Hard Rock Casino, with the appropriate ceremonies and respect from their own people. There was no living tribe to claim the Tocobaga bones, as that tribe

is now considered extinct, so they, too, were buried in a separate mass grave at Oaklawn.

It is worth noting that with all the intervening years, there is no way to be certain that *all* of the human remains were removed from the site before construction continued. Perhaps that accounts for the strange occurrences in the Fort Brooke Parking Garage to this day. People say they have seen shadows cast upon the walls when there was no living being present to cast such a shadow. The sounds of chanting and Native American drums have also been heard. A strange feeling often overwhelms those who walk into the stairwells. One young lady who works in one of the nearby banks parks there every day, noting, "When you park in most parking garages, you feel creeped out because you are alone. In the Fort Brooke Parking Garage, you feel creeped out because you know you are *not* alone!"

The Legend of Jose Gaspar

If you have been in Tampa in mid-January, you most likely witnessed a huge party. In fact, it would have been difficult for you to avoid it. The Gasparilla Festival is like a Mardi Gras celebration but with boats and pirates. Is it a festive commemoration of Tampa's pirate heritage? A remembrance of historical events? An excuse to gather beads and drink? Perhaps the truth is a little bit of all three.

The word "Gasparilla" means "little Gaspar." According to legend, Jose Gaspar was very short of stature. However, he was a gifted navigator, a fine swordsman and a man of intelligence and ambition. Born in Spain in 1766, he worked his way into high position in the court of King Charles III. But as often happens in political situations, other members of the court became jealous of his success and plotted against him. The plotters convinced the king that Jose was guilty of treason. As a result, while Jose was out at sea, his mother, wife and infant son were murdered and his home burned to the ground. Orders were given for his immediate arrest upon his return to Spain.

However, one of Jose's friends got word to him, and he never returned to his homeland. Understandably embittered, he vowed to "henceforth be an enemy of Spain." Notice that he did not say he would become a pirate, just an enemy of Spain. However, he soon found the fat merchant ships of Great Britain and the United States irresistible, and he began to prey on any ship

he could find along the coastlines of Florida. Some even claim that Captiva Island, near Fort Meyers, is the place where Gaspar held female captives until they could be ransomed by their families. Of course, male captives were given only the choice of a life of piracy or death.

Today, Tampa's Gasparilla Festival celebrates a battle between Gaspar and American forces that supposedly occurred in Tampa Bay in 1821. There is a huge "invasion" during which large numbers of boats enter the harbor and disgorge their pirate crews. These marauders then "kidnap" the mayor and hold him until he turns over the key to the city. What follows is two days of revelry, including parades where beads are thrown to excited—and often inebriated—onlookers.

But according to the legend, Gaspar was not victorious in his last battle. An American pirate-hunting vessel, the USS *Enterprise*, disguised itself as a British merchant ship and took Gaspar by surprise. When it was clear that the American forces would win the battle, Gaspar vowed he would not be taken alive to face the hangman's noose. So he wound the anchor chain about himself and threw himself and the anchor into the sea, crying, "Gasparilla dies by his own hand, not the enemy's!"

And to this day, it is said that you should not stand alone on the deck of a ship in Tampa Bay. For if no one is with you and no one is watching, the ghost of Jose Gaspar will rise up from the depths, still wrapped in the anchor chain. His hair is filled with seaweed, his eyes are gone and his pale face drips with water—and he'll grab you and drag you down!

It's a great story, but there's not a word of truth in it. Shhh—don't tell the Tampa Chamber of Commerce. No historical record of Jose Gaspar has ever been found. No one can find even a mention of his name until the twentieth century. But that does not stop people from believing the legend. The disappearance of a ship's captain from the deck of the *Genevieve* in 1925 is often attributed to the piratical ghost.

So just where does this legend originate? It turns out that the infamous pirate was the invention of a man named Juan (or sometimes John) Gomez. We do know that Juan did spend some time in the brig at Fort Brooke. We do not know on what charge, although it is possible it may have been piracy. After his release, he went out the southern tip of the peninsula that forms Tampa Bay, the area we now call Pass-A-Grille. There, in the years before the Civil War, he became the first tour guide in Tampa Bay. He found an old Spanish well and cleaned it out to provide fresh water. He built a huge fire pit and crude wooden benches. Then, in his small boat, he would ferry passengers out to the barrier island for picnics. His guests would watch the

sunset, have their picnic suppers and listen to Juan tell tall tales around a roaring fire. Juan was never one to let the truth get in the way of a good story, and he found that the wilder his stories became, the more customers he had. And the more customers he had, the wilder his stories became. And thus, the legend of Jose Gaspar was invented.

The Civil War put an end to Gomez's tourism endeavors. Instead, he used his boat for the benefit of the Confederacy, running blockades and harassing Union ships. After the war, he moved out of the Tampa Bay area, farther south to an island called Panther Key, near modern-day Fort Meyers. There he married, although he never had children and continued to live a quite happy, if not very rustic, life.

The *Fort Meyers Press* published an article about Juan on June 14, 1894, at which time he claimed to be 113 years old. The *Press* described him as short and heavy, with a thick, curly beard, which may have once been black but had now gone gray. In the interview, Gomez claimed not only to have sailed with Jose Gaspar but also that he knew Napoleon personally and was with him at the Battle of Waterloo. He also said that he had been in the Battle of Lake Okeechobee during the second Seminole War, serving under General Zachary Taylor. Gomez was indeed a busy man.

The *Fort Meyers Press* reported Juan's death on July 19, 1900. According to the article, Juan had lived to be 122 (however, since the paper reported that he was 113 in 1894, someone's math was obviously a little off). But here is where things get a little strange. Apparently, on the day of his death, Juan had gone out fishing and, while casting for bait, had become entangled in his own nets. He fell overboard and drowned. His rapidly decomposing body was found days later, hanging from his boat by one of his feet, still entangled in his nets.

So, Juan died very similarly to his fabricated pirate, Jose Gaspar. Both men drowned, Juan bound by his nets, just as Jose had been bound by the anchor chain. Sometimes truth is stranger than fiction.

Part II
The Old City Cemetery

Oaklawn Cemetery

On the corner of Morgan and Harrison, just outside of downtown, stands Tampa's oldest and most haunted cemetery. Originally known simply as the Tampa City Cemetery, it was created in 1850, when Tampa was a struggling town of about five hundred. In those days, the grave markers were mostly wood (usually carved cypress), and many of those rotted away. Even worse, the plat of the cemetery was misplaced sometime shortly after the Civil War, and the locations and identities of many early interments were lost. Wherever you place your feet, you may be standing on a long-forgotten grave. No wonder the spirits are restless within these walls.

In many ways, Oaklawn is typical of other graveyards of the era. Cemeteries of that time were designed to be pleasant places to come and walk, sit or even picnic while visiting the final resting place of loved ones. Some of the markers are beautifully carved, almost works of art. Old live oaks provide shade, and Spanish moss trails in the breeze.

No new burials will occur in Oaklawn. The most recent was in 2008, and the cemetery is now considered completely full. It is currently maintained by the Tampa Parks and Recreation Department, and you can still visit any day. Just pass under the metal arch that reads "Oaklawn Cemetery" and wander the cobblestone paths—but remember that they

lock the gates at 6:00 p.m. Be sure to be out by then, unless you want to spend the night with some of the ghosts of Tampa's past.

Dr. John P. Wall

On the right-hand side of the main path in Oaklawn, just past the first crossroad, is the Yellow Fever Memorial. This mass grave contains an unknown number of victims of the yellow fever outbreaks that raged in Tampa during the nineteenth century. This often-fatal form of hemorrhagic fever created havoc in many communities throughout the South. Tampa had five outbreaks between 1850 and 1905, the worst having come in 1887–88. The locals did not know the cause of the illness. A prevalent belief at the time was that diseases were caused by foul odors, so the victims were often buried quickly in mass graves in hopes of containing the disease. Ironically, a local doctor, John P. Wall, is buried in a family plot not far from the mass grave. He was a Tampa pioneer who served in the Confederacy during the Civil War even though he was not in favor of the Confederate cause. He simply felt it was his duty to care for the wounded. Wall served as mayor of Tampa from 1878 to 1880 and founded the first hospital focused solely on yellow fever patients. He contracted the disease himself but recovered. However, his family was not so lucky. His beloved first wife, Pressie, who is also buried here, and their infant child died of the dreaded disease. Wall embarked on a lifelong crusade to find the cause of the scourge that had taken his family. Eventually, he came to the conclusion that yellow fever was spread by mosquito bites. We now know that theory to be true, but at the time, he was widely disbelieved and even laughed at. Perhaps his spirit wanders the grounds today just to say, "I told you so."

Also buried in that family plot is John's son Charles. Although some believe he haunts the cemetery, his ghost is more often associated with another location that will be discussed later. For now, suffice it to say that Charlie Wall is someone you would not want to run into, even when he was alive.

Vincent Martinez de Ybor

The cemetery itself was originally divided into two parts. The part nearest the front was nondenominational. But the rear was known as St. Louis Cemetery and was consecrated ground for Catholic burials. The name "St. Louis" can still be seen in paving stones along the dividing line between the two parts.

Aboveground interments are unusual in Oaklawn. But there is one very large white mausoleum on the right side of the path in the Catholic section. It was constructed for a specific reason: the man whose body is inside had hoped to be moved elsewhere.

Vincent Martinez de Ybor is a name that all locals, and indeed many visitors, find familiar. He was the "Cigar Baron" who brought fame to Tampa as the cigar capital of the world. Born in Valencia, Spain, Ybor went to Cuba as a very young man. He worked his way up from stock clerk to owning his own company before he was forty years old. But the taxes imposed by Spain made Cuba an unattractive place to do business. Tampa, with its deep-water port and railroad connections, became a great alternative. In 1885, Ybor purchased forty-four acres from the city and created a planned urban community that became known as Ybor City.

After several successful years (in its best year, his company made 90 million hand-rolled cigars), Ybor passed away in 1896. The funeral was attended by all the dignitaries of the area, including the railroad baron Henry B. Plant, the mayor and members of the city council. At the end of his life, Mr. Ybor had made it clear to his heirs that although he loved Tampa and Ybor City, his heart remained in Cuba. His last request was that his body be sent to Cuba as its final resting place. However, since the Spanish-American War was looming on the horizon at the time, it was deemed necessary to place his body "temporarily" in the impressive vault. The plan was for his body to be moved to Cuba when the war was over. As of 2013, it has been 117 years, and still his body is here. And as of today, there are no plans to ever move it. But there are some who say that Vincent Martinez de Ybor does not rest in peace. The figure of a balding, mustached man wearing a dark suit, black bow tie and round spectacles has been seen wandering the grounds at night. Those who have seen him say he has a lost and puzzled look. Perhaps he is simply wondering, "What part of Cuba is this?"

Charles Owen

Midway between the Ybor mausoleum and the yellow fever marker lies a simple granite marker that reads, "Charles Owen Hanged 1882." "Hanged" is not this person's last name but a description of how he came to be there. And perhaps "hanged" is too kind a word for it.

In the early morning hours of March 6, 1882, someone broke into the home of a wealthy family at the edge of town. The perpetrator not only attempted to steal items from the house but also attempted to rape the daughter of the family, Ada. He was chased away by Ada's father but left evidence behind. That same day, Tampa sheriff D. Isaac Craft arrested a white transient named Charles Owen, who had been doing odd jobs about town and appeared to be homeless. He seemed to be the most likely suspect, and his rootless lifestyle contributed to the suspicions of the sheriff.

However, the frightened and angry citizens of Tampa were not satisfied with just the arrest. A group of twenty men went to Sheriff Craft's home and forced him to hand over the keys to the jail. At the jail, a group of one hundred or more men and women had gathered, and they were all clamoring for vigilante justice. Owen was dragged from his cell, strung up on a tree in front of the jail and left swaying in the breeze as the mob finally dispersed.

Owen was probably guilty. A knife found at the scene was known to be his, and Ada and her father both said he was the man who had been in their home. Still, his death at the hands of an enraged mob without benefit of a trial is a blot on Tampa's history. At least he was buried here in Oaklawn and a simple marker placed.

But apparently Owen's spirit is not satisfied with the gesture. He has been spotted wandering the grounds, his head slightly askew from his broken neck. And sometimes at sunset, the shadow of a man hanging from a noose and swaying gently appears among the live oaks around his grave.

Mayor Lancaster

Joseph B. Lancaster was the first mayor of Tampa. But that was actually at the end of his political career. Born in Kentucky in 1790, he was a lawyer and a member of the Whig political party. He was the fourth mayor of Jacksonville, serving in 1846 and 1847. He was then elected

to the Florida House of Representatives in an election tainted by accusations of fraud. When he was elected speaker of the House, the membership humorously resolved to rename the chamber the "House of Lancaster" and require the representatives to wear red roses. He served on the Florida Supreme Court from 1848 to 1850.

Lancaster was elected mayor of Tampa in February 1856 but became ill later that spring. The vice mayor, Darwin Branch, took over his duties late that same summer, and Lancaster passed away on November 25. All the historical records are silent about the nature of his illness, and some have gone so far as to suggest that Lancaster took his own life. Could depression be what kept him from his duties as mayor of Tampa? I fear we will never know.

A persistent mystery surrounds the grave of this prominent early Tampan. While local records, his Masonic lodge's accounts and a headstone confirm that Lancaster was buried here, a second grave and memorial stone also exists in the city cemetery in Jacksonville. I personally think that is okay—after all, he was a politician. As the brochure for the walking tour of the cemetery quips, "He should have no trouble lying in two places at once."

But the question of where is his body is actually located remains. I guess that, short of digging up the graves, it is another thing we will never know.

Darwin Branch Givens

Not all of the ghost stories in Oaklawn are associated with old graves. Very near the front wall is the grave of Darwin Branch Givens, who was born in 1858 and died in 1942, just a few days shy of his eighty-fourth birthday. What makes this spot interesting is not the grave marker itself, which is lying flat, but the additional stone that is standing upright. Placed there by the Tampa chapter of the Daughters of the Confederacy, it reads:

As a young child
he alerted Tampa
of the invading Yankee Soldiers
with the cry, "The Devils are Coming"
1864

For his bravery as a boy, he was actually granted a Confederate soldier's pension long after the war. But those who pass near this stone swear they hear the sound of a child's voice yelling out, "The Devils are coming!"

William and Nancy Ashley

Going back toward the front gates, just off to the right, is what is perhaps the most celebrated grave in Oaklawn. It is certainly the most curious.

Imagine yourself in Tampa before the Civil War. This was indeed the rugged Florida frontier. There was no rail service, no paved roads and no buildings over three stories high. The rough little settlement had barely survived the great gale of 1848 (hurricanes were not named until much later) and the Seminole Wars. The only way to cross the Hillsborough River was either via a single-plank footbridge or an unreliable ferry. It was in these harsh conditions that William Ashley became an important part of Tampa history. Ashley arrived here in 1837 at the age of forty-two, having brought his "wife" with him. I put the word "wife" in quotes because the couple could not be legally married. Nancy Ashley was, in fact, William's property, an African American slave. But the two loved each other very much. In fact, the couple had left William's parents, wealth and plantation behind them in Virginia just because they wanted to be together. I wish I could say that the residents of the frontier town of Tampa accepted them with open arms. They did not. But at least they tolerated them. And William quickly gained the respect of the community.

On the 1850 census, Ashley lists his occupation as "bookkeeper." But he was so much more. He began as the clerk of the army trading post at Fort Brooke and became prominent enough by 1847 that one of Tampa's first streets was named after him. Even today, the busy avenue that runs parallel to the Hillsborough River bears his name. In 1856, he was elected clerk of the City of Tampa, the first person to hold that office.

Of course, after the Civil War, Nancy was freed. But she stayed with William, and they continued to live together. They could still not be married, as there were laws in Florida and the rest of the South against interracial marriage. The 1870 census shows them living together, but Nancy is listed as his "cook."

After a lingering illness, William died, most likely in 1871. He was buried in the Tampa City Cemetery. From the beginning, this cemetery was open to all, rich and poor, black and white. There was even a special

section for "marginal persons" such as prostitutes, homeless and executed pirates. But the white and black sections were always kept separate. William was buried in the whites-only section. About a year later, Nancy died. John Jackson, another prominent Tampa pioneer, was the executor of William's estate. He knew that William and Nancy wanted to be buried together, but he could not legally buy a plot for Nancy in the white section. So he had William's grave opened, over a year after his death, and placed Nancy's body in the grave with her beloved.

We must reconstruct the aforementioned scene in our imaginations, as no written record survives. Was it done surreptitiously, sadly, in the half-light of dusk or even the dead of night? Or was it done boldly, in the sunshine, with Jackson daring anyone to stop him? However it was done, about a year later, Jackson had a headstone made. The epitaph seems to prove that no matter the circumstances, love will find a way:

> *Here lies*
> *Wm. Ashley and Nancy Ashley*
> *Master and Servant*
> *Faithful to each other in that relation*
> *In life in death they are not separated*
> *Stranger consider and be wiser*
> *In the Grave all human distinction*
> *of race or cast mingle together*
> *in one common dust.*

Below the epitaph, Jackson added the following:

> *To commemorate their fidelity in each other*
> *This stone is erected by their Executor*
> *John Jackson, 1873*

It's a wonderful story, sweet and sad, and very meaningful even to this day. But it isn't really a ghost story. Or is it?

This story is told as part of one of the ghost tours in Tampa. When the tours first started, one of the tour guides decided that she really couldn't tell the story without visiting the grave. So back in 2010, she and her husband paid a visit to the cemetery on a Saturday afternoon. The cemetery is very large, and they wondered how they would find the grave. Hoping to find a map, they stopped by the sexton's house. But as burials

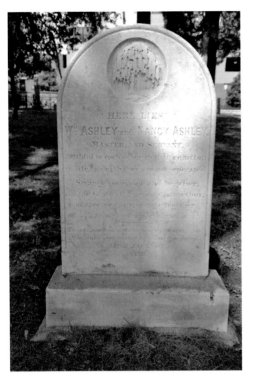

The headstone of William and Nancy Ashley, Oaklawn Cemetery. *Author's collection.*

are no longer taking place, the house is not staffed, and they decided they would just have to wander around to try to find it. It seemed unlikely, yet as they started to walk down the path, they found themselves drawn to the spot and right to the stone.

A different ghost-tour guide was telling this story during the Halloween season of 2011 when one of her guests said, "Oh, that's creepy!" The guide replied, "I don't think it's creepy; I think it's sad and sweet."

"You don't understand," came the reply. "We are cemetery buffs. Whenever we visit a new town, the first thing we do is look for the oldest cemetery and go and explore. Not six hours ago we were standing at that very grave, wondering about the story behind the strange epitaph. We have never taken a ghost tour in our lives, but something drew us to take your tour tonight. And here you are, not six hours later, telling us the story we wanted to hear."

So it seems that William and Nancy *want* their story to be told. Many have said they can feel their presence if they stand beside the grave. Perhaps it's proof that love never dies.

St. Paul's AME Church

Next to the cemetery is a redbrick church with stained-glass windows and polished wooden doors. This is St. Paul's AME Church. Tampa's official poet laureate, James E. Tokley, wrote "The Epic of St. Paul AME Church" in 2009. The poem begins:

The Old City Cemetery

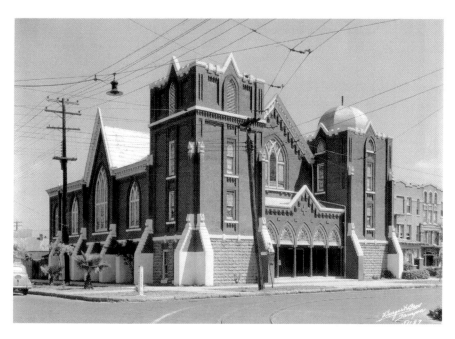

Above: Exterior of St. Paul's AME Church. *Courtesy of the Tampa-Hillsborough Public Library System.*

Below: Interior of St. Paul's AME Church. *Courtesy of the Tampa-Hillsborough Public Library System.*

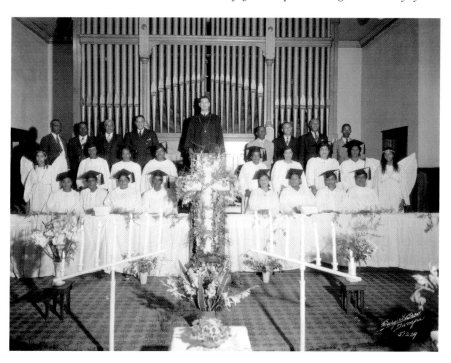

And up from slavery, ten years dead
was born an AME Church instead.
The first black church to find its place,
In the city of Tampa's lily-white space.

The letters AME stand for African Methodist Episcopal. This congregation was formed during the Reconstruction period after the Civil War—hence the poem's reference to slavery as "ten years dead." The building that now stands at 506 Harrison Avenue was completed around 1917. At that time, the congregation had four hundred members. Many famous people have stood in the pulpit, including Reverend Jesse Jackson, Supreme Court justice Thurgood Marshall, President Bill Clinton and the Reverend Dr. Martin Luther King Jr. But the last service held within those walls was on August 29, 2010. By that time, the active members had dwindled down to fewer than one hundred. The congregation does still exist to this day, but it now shares a much smaller church building with another group.

Sitting empty for nearly two years, this local landmark had been on the list of Tampa's most endangered historic buildings. Then, in 2012, along came the Metro 510 apartment complex. Built next to and surrounding the church structure, this 120-unit apartment building is very reasonably priced for downtown Tampa, with one-bedroom units starting under $600 a month. The old church has become the "Life Center" for those who live in the apartments. It is a place to "chill and play," according to the apartment complex's website. And LED lights have been placed behind the stained-glass windows, allowing them to shine as a form of public art.

But some who use the facility think that a few restless spirits remain within its walls. Late at night, people have seen unexplained lights inside the church. And sounds fill the air in the form of a gospel choir, a fiery preacher's voice and fervent shouts of "Alleluia." Perhaps they are quoting the poem once again. Its last stanza is as follows:

So, Brothers and Sisters, Christian Friends,
With God's good grace, we say, "A-men!"

PART III
DOWNTOWN

THE HOTEL FLORIDAN

The bright-orange neon sign is visible from miles away, standing out clearly against the Tampa skyline. It reads "Hotel Floridan," although many who look quickly assume it says, "Hotel Floridian." Indeed, there is only one "i." Although the sign has recently been completely repaired and restored, there are always some letters not quite working. Often, the "o" in "Hotel" blinks on and off. Or the "e" goes out completely one night only to work perfectly well the next night. Perhaps it is the work of the resident ghosts.

The Hotel Floridan stands on Florida Avenue between Cass and Tyler Streets. According to the current proprietor, the original owners liked the name because it was straightforward and easy for them to trademark and protect. Construction was begun in 1926. The building was designed by the prominent Tampa architectural firm of G.A. Miller and Francis J. Kennard. Officially opening in 1927, it had 316 rooms and cost $1.9 million to build. At nineteen stories, it was the tallest building in Tampa. It retained that distinction until 1960.

In its heyday, the Floridan was the place where the rich and famous would stay when visiting Tampa. Clark Gable, Jimmy Stuart, Charlton Heston and boxer Jack Dempsey all stayed here. Gary Cooper stayed here during the filming of *Hell Harbor*. In 1955, a young upstart rock-and-roll singer by the name of Elvis Presley stayed here. Although he was just beginning his music

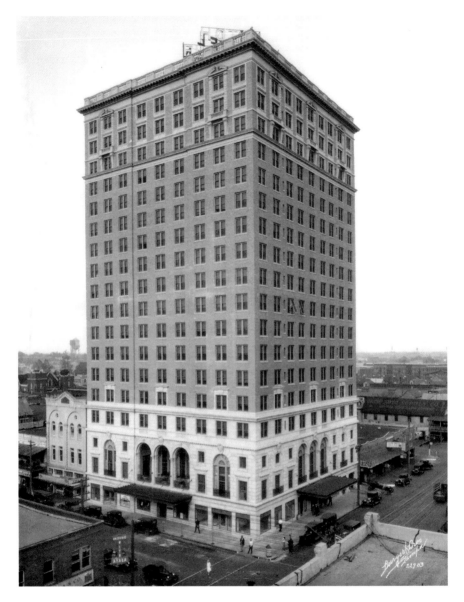

The Hotel Floridan. *Courtesy of the Tampa-Hillsborough Public Library System.*

career and not yet known as "The King," he could afford the best hotel that Tampa could offer. And that was definitely the Floridan.

But like many grand old hotels, such as the Vinoy in downtown St. Petersburg, the Floridan suffered a period of decline. By the 1960s, most

people preferred more modern accommodations outside of the inner city. After all, parking was a hassle, and rooms in old hotels were small. What had once been a glorious showpiece was becoming run-down. The center of activity in Tampa moved away from that part of town. Nearby stores and restaurants were closed, and skyscrapers were built nearer to the bay. Business was bad for the old Floridan.

The hotel closed to travelers in 1966 and instead had long-term renters. Just imagine those small hotel rooms, all of which had baths already attached, turned into little studio apartments with the addition of tiny kitchenettes. Talk about high-density housing! Things were even worse by the 1980s, at which time the once grand and luxurious hotel had become a residence for transients, renting rooms by the week or the month. Social workers would rent rooms for the homeless on those few nights when it got really cold in Tampa. Once a palace, the Floridan was now little more than a flophouse. Conditions continued to deteriorate. In 1985, the owners refused to spend the money to meet fire codes, and the Floridan was closed. It seems unbelievable, but the grand structure stood empty for over twenty years.

According to a July 27, 2012 online article from WTSP.com, most people thought the hotel could never recover. "They said it was so crummy that even the homeless wouldn't live there," noted the article. "They said it was so hopeless that vultures—symbols of the dead—nested in its upper floors."

But all that changed not very long ago. In 2005, Antonios "Tony" Markopoulos, a hotelier and real estate investor, purchased the aging relic for $6 million. That may sound like a bargain, but it definitely was not. The roof had collapsed at some point, and the upper floors were water damaged and decaying. The foundation of the building had shifted, so Tony's first expense was to stabilize the structure and repair the roof. He has since spent well over $20 million in renovations. It is unlikely that he will ever recoup the money he has spent. It has been a true labor of love. The Floridan celebrated a grand reopening on the last weekend of July in 2012—just in time for the Republican National Convention held in Tampa that summer.

The first three floors of the hotel have been completely restored. The Markopoulos family preserved the few remaining original items: the marble floors, the brass handrails on the stairs, the marble front desk and the old "key box" behind the desk. If you stand in front of the desk, you can even feel the depression in the marble below your feet, caused by all those years of people standing there to check in or out.

The upper floors have been remodeled, as all of those original small, 1920s-style rooms are gone. The rooms are much larger now. Today, there

are only 195 rooms, 3 penthouse suites and 15 junior executive suites. And there is an additional twelve thousand feet of meeting space.

On the ground floor, on the corner of Cass and Florida, is the Sapphire Room. This was the lounge of the hotel from its earliest days. Although, there should not really have been a lounge in 1926, as Prohibition was still in effect and alcohol was illegal, remaining so until 1933. Whether the liquor was legal or not, the Sapphire Room was always known as the place to have a good time. During World War II, the GIs referred to the bar as the "Surefire Room," as they were certain they could make a hook-up with a girl. The bartender during the war years, Gus, obligingly invented a strong cocktail with a very sweet taste. It was appropriately known as the "Between the Sheets Martini." Gus guaranteed that if you could get your girl to drink just two of the tasty concoctions, you could definitely get her "between the sheets." The Sapphire Room was also a hangout for the local gangsters, especially the mobsters from nearby Ybor City. Remember Charlie Wall from Oaklawn Cemetery? He frequented the Sapphire Room until the day he died.

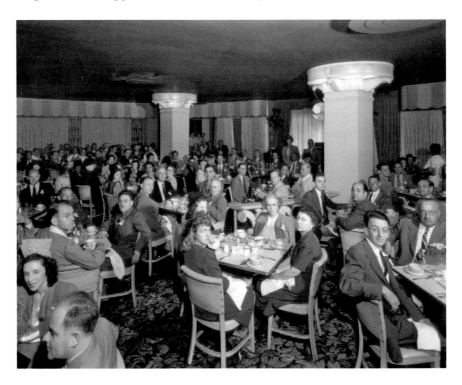

A banquet in the Sapphire Room at the Hotel Floridan. *Courtesy of the Tampa-Hillsborough Public Library System.*

One ghostly story of the Floridan concerns the Sapphire Room. On December 7, 1941, a young man from the nearby U.S. Army Air Corps base was relaxing over a drink during some well-deserved "R and R." It has even been said that the drink was a Between the Sheets Martini. The young man was Colonel Clarence Tinker. He had not been in the bar too long when some friends from the base came to find him and tell him that the Japanese had attacked Pearl Harbor, initiating the war. Naturally, they all rushed back to the base. Tinker, an Osage Native American, was eventually promoted to major general, the first Native American to achieve such a high rank in any branch of the U.S. armed forces. Unfortunately, he was also the first U.S. Army general to die in World War II. During the Battle of Midway, his plane went out of control and crashed into the sea. His plane, his body and those of his eight crew members were never found. However, Tinker's spirit seems to have found its way back to the "sure fire" room. He has been seen sitting at a small table in a corner between the bar and the piano. He is described as a young man with dark hair, wearing a military uniform. He holds a drink in his hands, and he is staring sorrowfully down into the glass, as if contemplating a sad and uncertain future. If anyone approaches him or tries to engage him in conversation, he simply vanishes into thin air.

Now that the Floridan has reopened, so, too, has the Sapphire Room Lounge. Stop by on a Friday or Saturday evening and say hello to Tony Kovach, who plays the piano just as he did back in the 1950s and '60s. Tony has fond memories of the original Sapphire Room. "It was the place in town," he says. "It was usually packed six, seven nights a week." Although one does see empty tables at the lounge today, perhaps they are filled with revelers from the past, happy to have their old "haunt" open once again. If so, they like to make their presence known. One of the new bartenders reported that the round lights above the bar have turned off, in sequence, and then turned back on again in that same sequence. A check of the electrical system could find no reason for the strange occurrence.

There are many ghost stories regarding the Hotel Floridan. Most of them were reported during the period when long-term renters lived in the rooms. There have been stories of water faucets turning on and off by themselves, electric lights flickering for no apparent reason and strange sounds of music and laughter heard in the hallways. One of the best stories about the hotel was related by the daughter of the woman, now deceased herself, who had the actual experience. She said her mother had been one of those long-term residents and had lived there through most of the 1970s. She also said her mother was "sort of old-fashioned and even in the mid-'70s had an old-

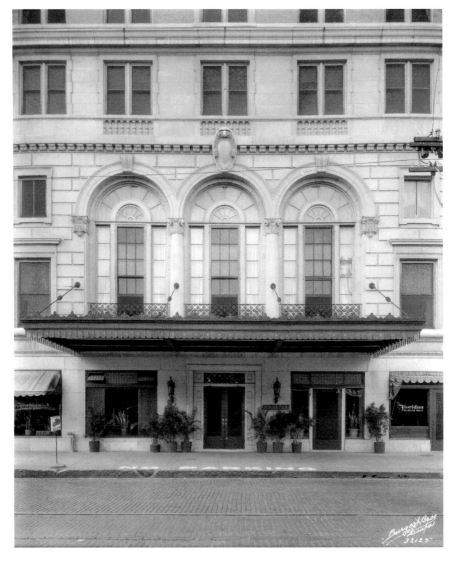

The entrance of the Hotel Floridan. *Courtesy of the Tampa-Hillsborough Public Library System.*

fashioned radio with no batteries. It had to be plugged in to work, and it had two large knobs: one to turn it on or off, and one to tune in a station." One day in 1977, the woman's mother turned on that radio as she prepared her breakfast. A song by Elvis Presley was playing. This was not a problem, as she liked Elvis. However, as soon as the song finished, her radio dial began

to move all by itself, seeking out another station. Another Elvis song began to play. As you can imagine, she was quite surprised. She turned to look at the radio, which once again began to retune itself, once again settling on a station playing an Elvis song. Now frightened, the woman turned off her radio. Without her touching it in any way, the radio turned itself back on and resumed its bizarre seeking of Elvis songs. She unplugged the radio, but again it turned itself on, and the sounds of "Heartbreak Hotel" filled the room. Unnerved, the woman decided to leave her apartment for a while. She locked her door and took the elevator down to the first floor, where she ran into a friend in the lobby who said, "Did you hear the bad news? Elvis Presley died last night."

The next day, the woman's radio worked just fine.

Could this have been the spirit of Elvis himself, visiting the hotel where he had once stayed in his early days? Was he just wanting to make his presence known? Or perhaps it was one of the other spirits of the Floridan, who happened to be an Elvis fan, taking advantage of the fact that nearly

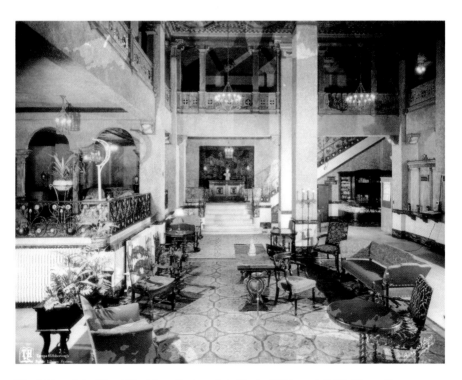

The lobby of the Hotel Floridan. *Courtesy of the Tampa-Hillsborough Public Library System.*

every radio station in town was playing Elvis Presley music on the morning after his death?

During the years that the hotel has been empty, many people claim to have seen eerie lights in the windows and even misty faces peering out. If the spirits have remained in the hotel all these years, I think it is unlikely that they will move away now that the Floridan has reopened. In fact, there have already been a few strange occurrences. Guests have reported feeling the mattress move while lying in bed, as if someone was sitting on the bed next to them. One guest even claimed that a ghostly apparition showed up in a photograph she had taken in her room.

As for those neon letters on the roof, it is the original sign. It was found by work crews in the dusty Sapphire Room during the cleaning of the building in 2005. The sign was not working and was covered with layers of old paint. It required extensive restoration to bring it back to working order. However, when Mr. Markopoulos was ready to put the sign back on the roof, he was told by city inspectors that current codes do not allow the placement of signs on the roofs of tall building. (If you look at the other buildings in downtown Tampa, you will note that their neon signs are located on the sides of the buildings, near but not on the roofs.) Tony appealed to the city council and was granted permission to place the sign on the roof because it was an original historic sign to be placed in its original location. The bright-orange neon was placed on the rooftop once more in the late summer of 2008. Now, if they can just get the ghosts to leave it alone.

The Tampa Theatre

On the corner of Franklin and Zack in downtown Tampa, embedded in the sidewalk, is a round brass circle about two feet in diameter. It was placed there in November 2012 by the City of Tampa to honor one of its true gems, the Tampa Theatre, which sits just kitty-corner at 711 North Franklin Street. There are three important images in the brass. The first name and image is that of John Eberson. The picture shows a rather handsome man with wavy hair and a mustache. This is the famous architect who designed the theater in 1926. Born in what is now the Ukraine in 1875, Eberson was well educated in Dresden and Vienna, where he studied electrical engineering. He came to the United States in 1901 and designed his first theater (the Jewel in Hamilton, Ohio) in

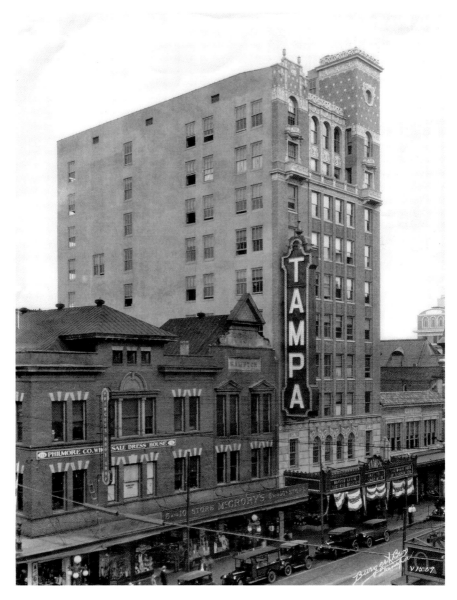

The Tampa Theatre marquee. *Courtesy of the Tampa-Hillsborough Public Library System.*

1925. He went on to design over 150 movie houses all over the world, including theaters in Europe and Australia.

Eberson refused to call his creations "theaters"; he preferred the term "movie palaces." He wanted the patrons to feel as if they were royalty. He

loved depicting outdoor spaces indoors, and the Tampa is a prime example of that. The theater's interior was made to resemble a Mediterranean courtyard garden, perhaps that of the Duke de Medici. It is resplendent with old-world statuary, flowers and birds. The illusion of being outside is complete when you look upward, as the ceiling is made to resemble the night sky, with ninety-eight stars (more or less, depending on how many light bulbs need changing) and clouds floating overhead. And there was another good reason for the citizens of Tampa to want to go to the movies: the Tampa Theatre was the first building in town to have air conditioning. The theater's lobby has beautiful patterns in the individually laid mosaic tiles, and grotesques (like gargoyles but with no open throats for water) peer down from the second-floor level. Some people claim that their eyes will follow you as you move about.

The theater was designed for hosting silent pictures, which were often accompanied by live music. The Tampa originally had a pit that could accommodate a full orchestra, but it is now covered. Few silent films came

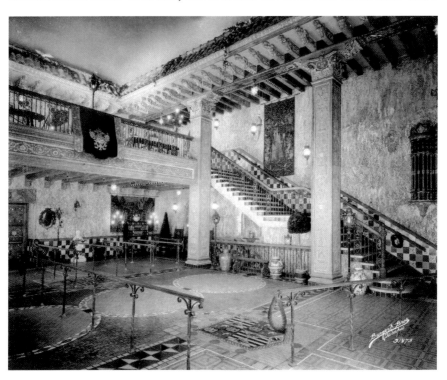

The interior of the Tampa Theatre. *Courtesy of the Tampa-Hillsborough Public Library System.*

with full scores, so the use of an orchestra was unusual. Most of the time, the accompaniment came from the Mighty Wurlitzer Theatre Organ. And for the record, "Mighty" is an official part of the name. The Tampa is one of only forty places in the world that still has its original Mighty Wurlitzer, with the pipes cleverly concealed behind balconies and façades. The console for the organ sits on a platform well below the level of the stage. When organ music is required, the entire platform, including the organ console and organist, rises up from below. When it is no longer needed, the platform and organ return to the lower level, leaving a large hole in the stage.

Mr. Eberson would be proud of the many honors that have been heaped upon his creation. The Tampa was declared a Tampa City Landmark in 1988, and in April 2007, *Life* magazine named it "One of America's 21 Wonders," a list that includes not just theater buildings but all types. And in 2013, the Motion Picture Association of America named the Tampa one of the top ten theaters in the world.

But John Eberson does not haunt the Tampa Theatre.

The second image on the brass plaque is an old-style movie projector with the name Fink Finley. Fink, whose real name was Foster, is one of the ghosts of the Tampa. In fact, he is the theater's most famous ghost. Fink first came to work at the Tampa in 1930, getting his job the old-fashioned way: nepotism. His brother, Obadiah Finley, was the manager of the theater. I'm sure Obadiah thought he was doing his brother a favor by getting him a job, but Fink became one of the best employees the theater had over its long history. He loved the movies, and he loved the Tampa Theatre. He would always arrive, by bus, very early. Even though the theater did not open until 1:00 p.m., Fink was usually there by 7:00 or 8:00 a.m. He had his own keys to the front door and the projectionist's booth. It was said that you could always hear him coming, as the big bundle of keys always jangled in his pocket.

Once Fink arrived at the theater, he would go to the concession stand and make himself a pot of coffee. Then, with the cup of coffee in hand and his customary cigarette dangling from the corner of his mouth, he would climb the long staircase to the projectionist booth, high above the stage. Once there, he would shave. And I'm not talking about an electronic shaver here. He would get a bowl of water, lather his face with shaving cream and use a razor, finishing off with lilac-scented aftershave. He would then change clothes, putting on a freshly pressed white shirt, black suit and black tie. Even though he was hidden away in the projectionist's booth, he felt it was important to be impeccably dressed. After getting settled in, Fink would sit all day watching and showing movies.

In December 1965, during a showing of that immortal classic *Santa Claus Conquers the Martians*, Fink collapsed in the booth. He was having a heart attack. (We cannot be certain if the quality of the film being shown was a contributing factor, but it has been voted one of the five worst films of all time.) He was whisked away by ambulance. People are often surprised that the famous theater ghost did not actually die in the theater. The truth is that Fink had worked at the Tampa for over thirty-five years, often coming to work six days a week. After his death, it seems his spirit was just so used to the routine that it continued to come in to the theater.

Of course, a new projectionist had to be hired. However, he claimed that he kept experiencing Fink's presence. He said that Fink "just wouldn't leave him alone." When he would walk up the long stairway to the booth, he would smell coffee, as if someone was walking behind him with a freshly brewed cup. He would turn quickly to find no one behind him. He would walk a few more steps and smell cigarette smoke. Once again, he would quickly turn, only to find an empty stairway. Upon entering the booth, he would catch a slight whiff of shaving cream, followed by the scent of lilac aftershave. And just before the show would start, the door to the projectionist's booth would slowly creak open all by itself. He would hear the jangling of keys, and the door would slam shut. He said the worst thing was that when it was time to change the big rolls of film on the projectors, he would feel a poke on his shoulder. Those pokes continued until he took care of the task. Once, he even felt an invisible hand shaking him by the shoulder. It didn't take long for that new projectionist to quit his job.

Since then, many projectionists have come and gone, but they all report similar occurrences, even after all these years. In fact, I talked to one current employee who said, "One of these days, old Fink is going to get me in trouble. People smell smoke in that stairway, and they think it's me. But it's really just Foster Finley, with that cigarette still hanging from the corner of his mouth." I guess it's hard to convince your coworkers that what they are smelling is a cigarette-smoking ghost.

Even people who "ghost hunt" for a living will tell you that the sighting of a full-body apparition is extremely rare. However, Tara Schroeder, who used to work for the foundation that runs the theater, believes that she has actually seen Fink. Tara's office was located on the other side of the theater, and she worked "business hours" rather than theater hours. One day, at about 9:00 a.m., before the theater was opened to patrons, she needed something from the lobby, and rather than walk all the way around, she decided to take a shortcut through the dimly lit "house" where the theater seats are. She was

the only one in the building at the time, and all of the doors were locked. She did not bother to turn on the lights because she knew her way so well. As she walked through the house, she was startled to see a man wearing a black suit, white shirt and black tie standing about three rows up from the stage. Her first thought was not "This is a ghost" but rather "Someone has broken into the theater." Tara is a pretty feisty young lady, so she ran to the panel of light switches, turned all the lights on and turned back to face the man. "You get out of my theater right…" But to her surprise, there was no one there. She searched the entire theater and even double checked to make sure all of the doors were securely locked. After a bit of reflection, she thought, "If someone is going to break into a building, they are unlikely to do it wearing a suit and tie. Perhaps the figure was just a transparency in the dim light." It dawned on her that she "might have just seen the ghost of Foster Finley!"

There is also the story of a theater custodian who had a pocketknife that he particularly loved. He was always playing with the knife, flipping the blade in and out and showing it to anyone who would take the time to look. Unfortunately, one day he laid the knife down somewhere and couldn't find it. He was sure that he had lost the pocketknife somewhere in the theater. That evening, he happened to watch one of those "ghost hunter" television shows, on which the suggestion was made that a spirit might help someone find a lost item. He thought it was worth a try, so one day, before the theater opened, he went up to the balcony and went down the six stairs that lead to the railing, walking carefully and watching his step. He placed his hands on the railing, bowed his head and said, "Oh, Fink Finley, ghost of the Tampa Theatre, help me find my pocketknife." Nothing—only the sound of his own words echoing off the wall of the vast space of the empty theater. He thought perhaps he may have been disrespectful by using Finley's nickname, so he raised his hands again and looked up into the starry ceiling. "Oh, *Foster* Finley, ghost of the Tampa Theatre, help me find my pocketknife." Again, nothing but the eerie echoes. Disappointed, he turned to go back up the six steps. Then, there on the third step, which he had just walked down a moment before, was his pocketknife, with the blade extended. Perhaps Foster may have been saying, "Well, I was having fun with it, but if you want it back all that badly, here it is."

The third image on the brass plaque is that of a lovely young woman with dark, curly hair, elegantly dressed and seated at the console of a large organ. The name accompanying the image is Rosa Rio. Remember that Mighty Wurlitzer Theatre Organ? Well, Rosa became the organist here in 1993. But the image in the pavement is from a picture taken at the Fox Theatre in

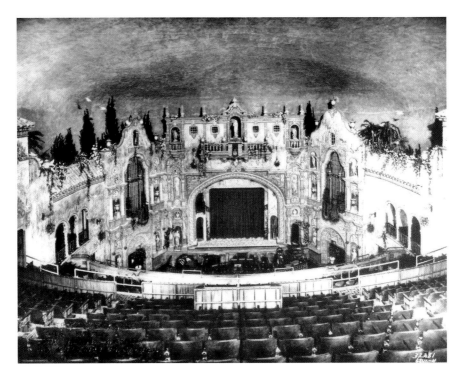

A view of the Tampa Theatre stage from the balcony. *Courtesy of the Tampa-Hillsborough Public Library System.*

Brooklyn sometime in 1933 or 1934. Rosa looked nothing like that when she came to the Tampa at the ripe old age of ninety-one. Born in 1902 in New Orleans, Rosa became a keyboard prodigy at the age of four, and she played for her first silent pictures when she was only nine. She said the day she saw *The Jazz Singer*, the first talkie, she broke down and cried because she thought she would be out of a job. But she was never out of work. She was quickly hired to play the sad, traumatic organ music that accompanied live "soap opera" on the radio. When television came along, she continued to play for years. She became known as the "Queen of the Soaps," as she played the organ for many of those "stories."

After retiring, Rosa ended up in Tampa. When she heard about the Mighty Wurlitzer Theatre Organ at the Tampa Theatre, she applied for a job. Of course, after looking at her resume, the theater was thrilled to have her. She was always very coy about her age; she never told anyone. One time, John Bell, the director of the theater foundation, had the temerity to ask her how old she was. Rosa, who was quite a tiny woman, got right up in

John's face, shook her index finger under his nose and said, "John, age is just a number—and mine is unlisted!" However, in 2007, Rosa played for a silent film festival on June 2, which happened to be her birthday (although no one knew what year). She must have been in a mellow mood that day, or perhaps she thought it no longer mattered, but she finally admitted, from the stage of the theater, that she was 107 years old. Rosa died on May 13, 2010, just three weeks short of her 108th birthday. Is it any wonder after all those years that Rosa is still playing? Sometimes when people pass by the theater late at night, after everything has been closed up, they hear the sounds of sweet organ music coming from inside the building.

In 2011, the theater had a showing of the original silent version of *Phantom of the Opera* with Lon Chaney. The gentleman who was scheduled to play the organ that evening came out beforehand to introduce himself and talk a little about the organ. Then he sat down to play. Several members of the audience said that the organ music that evening was fantastic. It almost seemed as if the sound effects and music were coming directly from the film, not the Mighty Wurlitzer. After the show, the organist came up on the stage. Everyone thought he was going to take a solo bow, but instead he said the following:

> *I do consider myself a good organist, but I have to admit that I have never played as well as I did tonight. And I only played so well because I had help. You see, I felt the spirit of Rosa Rio. It was as if she was moving my hands, arms and feet. Rosa gets the credit for tonight. It was her spirit playing the organ for you.*

On another occasion, Tara Schroeder (remember the woman who saw Foster?) was standing on the stage talking to someone. Not paying particular attention to where she was standing, she backed up a few steps and found herself falling into the hole on the stage, with the organ a story and a half below. But as she fell, she said she felt two small hands beneath her, one on her back and one on the back of her legs. She says it was as if someone was lowering her gently down.

Tara did fall on the organ. She said that she should have had broken bones or maybe even a broken neck. But all she had was a few scrapes and bruises. And there wasn't a scratch on the console of the Mighty Wurlitzer. Tara believes that it was the ghost of Rosa who helped her that day. And Rosa has her priorities in order. Save the girl if you can, but more importantly, save the theater organ.

A lady ghost has been seen in the balcony wearing a long white dress. A group of paranormal investigators claimed to have contacted her during a séance. They said her name was Jezebel and that she actually died in what used to be the dirt road out front, long before the theater was built.

And if that isn't enough, there may also be the ghost of an usher. Modern movie buffs are not familiar with it, but there was a time when an usher would ask you where you wanted to sit and then escort you to your seat, often with a small flashlight to show you the way. In its heyday, the Tampa always hired handsome young men to be ushers. They wore red uniforms. Sometimes, young ladies would go to the movies just to flirt with the ushers. One young man had a particular trick of spinning around on the spot as he took your ticket. He would tear it in half as he spun and hand you your ticket stub when he finished his rotation. One day, he arrived early and was practicing his fancy maneuver when he slipped and fell, striking his head and dying on the spot. His death is the only documented death in the theater. One paranormal group that was conducting an investigation of the theater brought a psychic who said that she sensed a spirit in a "red uniform." She thought perhaps it was a British soldier from the days when Florida was a British territory. But the theater staff thinks it may be that usher who lost his life inside the theater.

Theaters are notoriously haunted places. Some say it is because so many souls have passed through the doors. Others say it is because the many characters created on stage or screen impart an energy that invites the spirits. So it is no surprise that the beautiful Tampa Theatre is one of the most haunted places in the city.

The Tampa rarely allows séances or investigations on the premises. However, there are many reasons to visit this wonderful historic building. If you should find yourself in Tampa on the night of the Academy Awards, the Tampa Theatre is definitely the place to be. It is one of about forty theaters in the United States authorized to host an official Academy Awards party. For the price of a ticket, you can be driven up to the front door in a limousine and have your picture taken by paparazzi and your autograph requested, after which you can be briefly interviewed by "Roan Jivers." Inside, there is wine and hors d'oeuvres. You then get to watch the award ceremony on the movie screen. It's almost like being there for the real thing. Or better yet, you can always go there just to see a movie. Whether a talkie or silent picture, you are sure to have a good time. Just leave a vacant seat or two next to you for one of the Tampa Theatre's many ghosts.

Duckweed Urban Market

At 305 East Polk Street, tucked between the Tampa Theatre and the Hub Bar, sits a tiny store. As small as it is, it is downtown Tampa's only grocery store.

Mayor Bob Buckhorn cut the ribbon to officially open the store on October 14, 2011. The owner's name is Michele Deatherage. Yes, that really is her name. And it's not her maiden name either. She said when she met a man who had both the words "death" and "rage" in his last name, she just had to marry him. Ironically, one of the young men who works in the store is Derek Grimsley. So they have death, rage and grim all in one place.

Michelle says that when she was getting the store ready to open, she had only two helpers: Derek and another young man named Jensen. The tools they were using to fix up the old space would frequently disappear only to be found in ridiculous places. When leaving for lunch or for the evening, they would always put the tools on a table located in the center of their small space, locking the door behind them. Upon return, they variously found the screwdriver in the cooler for the soda, the hammer on top of the beer cooler or the nails in the sink. They began to suspect that they had a mischievous ghost roaming about the store.

Often, restoration or remodeling can cause spirits to become more active. It is almost as if they just don't like change, even if it's change for the better. Something Michelle, Derek and Jensen were doing was awakening at least one spirit in the market, but Michelle thought that perhaps things would calm down once the store was open. However, once they had opened, weird things continued to occur. They would come into the store in the morning and find that the retail displays had been rearranged from the night before—not thrown on the floor or jumbled, but carefully rearranged. The cookies were all moved to where the crackers had been, and the soup cans would be rearranged in a different order. The only explanation that they could find was that a ghost was responsible. They took to calling this ghost "George." After doing some research, they discovered that this entire corner was once occupied by an old-fashioned drugstore known as Madison Drugs, which later became a Walgreen's. They wondered if their ghost was someone who had been in charge of retail displays at one of those stores and was just trying to be helpful by "fixing" the displays.

Derek often works the late evening shift. One evening, he was stocking bottles in the beer-and-wine cooler, which is in a separate, small room. He could not see the front door. He had big-band music playing, but he was

also listening for the sounds of the door opening in case he got a customer. A few moments later, he heard the distinctive sound of the door, followed by the sound of someone whistling to the music. Derek hurried out to help his customer, but there was no one there. Quickly, he ran to the door and looked outside. There was nothing but a dark and empty street. Derek said he felt the hairs stand up on the back of his neck.

Another time, Derek was getting ready to close when he heard the sound of beer bottles falling in the beer-and-wine room. When he went to look, it was just as he had feared. Several bottles had broken and made a mess on the floor. What was odd was that the fallen bottles had not been anywhere near the edge of the cooler. They would have had to move themselves quite a distance before they fell on the floor. Derek wondered if "George" was feeling lonely that night and created a reason for him to have to stay a little longer and keep him company.

Women have said that when they walk down the small aisle where the spices are stocked, they feel as if they are being watched. And when they walk out again, they feel a hand brush the back of their hair. Only women report this happening, never men. Once, a couple was walking down that same aisle with a "Ghost Radar" app running on one of their cell phones. The woman did get the feeling that she was being watched, and just then, the ghost radar showed a red dot, which is a very strong indication of a presence, just on the other side of the shelf. At the same time, the app, which also gives words from time to time, said "shelf." The couple was startled, to say the least.

Duckweed now has a new employee named Forrest. He has had his experiences with the ghost as well. There are some shelves near the back of the store, on which the bags of chips are kept. Several times, Forrest has gone back to that corner to discover all the bags of chips covered in a thin, oily film. If he wipes the film off of the bags, it returns within a matter of hours. There is no possible source for this film in that area.

And the ghost keeps hiding the dustpan. When Forrest goes to clean up, the dustpan is not with the broom where he left it. In fact, it turns up in some very strange places—just like the tools did before the store was open. It seems that the Duckweed Urban Market's ghost is a creature of habit.

Recently, Forrest was standing at the sink, which is behind a black "velvet" curtain. He felt a cold breeze stir and lift the curtain behind him, but when he looked, there was no one there.

Some strange things have happened when people come into the store with ghost-hunting equipment. EMF (electromagnetic field) readers return high readings in the area near the chips, where Forrest has seen the film. And that

talking "Ghost Radar" app? Several times it has given the name "George." Could it be that the folks here at Duckweed hit upon the actual name of their ghost without knowing it?

Unfortunately, Duckweed Urban Market has left its original location behind and has moved to new, larger quarters a block away. It will be interesting to see if the spirit stays with the location or follows them to their new store.

The "Five and Dime" Block

On Florida Street, between Polk and Cass, three empty buildings are all that remain of what was once the "Five and Dime" block. The five-and-dime was a forerunner of today's dollar stores, but merchandise was often of better quality, and the selection was larger than what you see in a typical dollar store. They often had lunch counters or soda fountains as well.

The first building at 801 North Franklin was the F.W. Woolworth Company. Constructed in 1927, the front, which faces Florida Street, has a terra-cotta façade done in the Art Deco style. Unfortunately, it is now boarded up, and its beauty is hidden. But the red stripe that was a trademark for Woolworth's can still be seen.

On the other end of the block at 815 is the J.J. Newberry building. Its yellow-brick façade was built in the Moderne architectural style. The words "J.J. Newberry Offices" can still be clearly seen in the glass over the old metal doors. In its day, the building was considered to be noteworthy and important.

In the middle is the most beautiful of the three buildings, still proudly wearing the name "Kress." It towers over the other two and features façades on both Florida and Franklin Streets. The Kress chain, founded by Samuel Kress in 1896, eventually included 250 stores throughout the South and along the East Coast. Mr. Kress always wanted his buildings to be beautiful, almost a form of public art. This store, at 811 North Franklin, was designed by eminent New York architect G.E. McKay. Built in 1929, it replaced the original Kress building on this site, which was built in 1908. It was—and still is—a gorgeous building, just as Samuel Kress envisioned.

But time moves on, and this part of downtown Tampa was hit hard by changes. By the 1960s, suburban malls drew more customers than urban stores. Discount stores began to claim the former customers of the five-

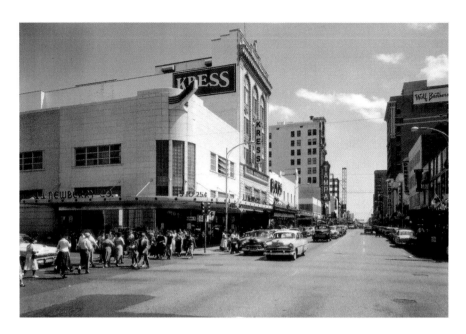

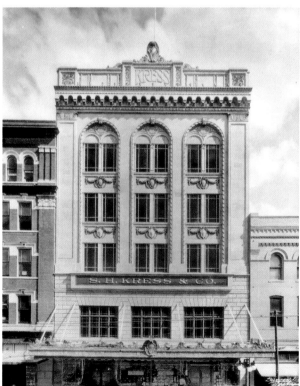

Above: The Newberry and Kress buildings on the "Five and Dime" block. *Courtesy of the Tampa-Hillsborough Public Library System.*

Left: The Kress building. *Courtesy of the Tampa-Hillsborough Public Library System.*

and-dimes. The business hub of Tampa moved away from the area around Polk and Franklin and closer to the river, where skyscrapers were built to house financial and service companies. No one came to Woolworth's, Kress or Newberry anymore. The Kress closed in 1980, and J.J. Newberry soon followed. The Woolworth store hung on until 1992, when it, too, succumbed to progress. Since that time, all three buildings have sat forlornly empty, derelict and boarded up.

The city hoped to find something to do with the old buildings. There was a plan put forth to tear down Woolworth and Newberry and build a huge condominium complex that would utilize the façades of the Kress building. However, when the housing bubble burst, that plan was scuttled. Things were looking bleak indeed.

Recently, however, hope came to the decaying block in the form of the 2012 Republican National Convention. Rumors began circulating in early August that the empty buildings would be the site of a huge party. And sure enough, the boards on the Kress building were torn down, and modifications were made that reportedly cost $660,000. And there was indeed an event during the convention. By all accounts, it was a night to remember. The party was by invitation only, and those invitations were not easy to get. It was billed as the "Truly Legendary Warehouse Party." The main hall featured a rotating bar, and the Woolworth area housed a huge dance floor, with a stage for the musicians that looked like a pirate ship (this is the home of Gasparilla, after all). Sand was carted in, along with potted palms and bamboo trees. Beach chairs and hammocks completed the ambiance of the RNC's "beach party" in downtown Tampa.

After the party, the current owner of the property, the Doran Jason Real Estate Group, did not put the boards back up in front of the Kress building. Instead, it has put in beautiful glass doors and windows that allow passersby to see the interior. The glass light fixtures that once provided light to shoppers are still visible, as is the stairway leading down to the basement level. The entire first floor from the Franklin Street entrance to the Florida Street entrance can now be clearly seen. There are plans to incorporate the existing buildings into a new structure that will house apartments, office space and parking.

But those who live and work in these new spaces, if they come to fruition, may have to contend with a few residents from the past. Since the boards have been removed and glass installed, there have been unexplained lights seen at all hours of the night. The windows on the upper floors open and close without anyone being anywhere near. Are

these the restless spirits of shoppers hunting for bargains or those of workers who staffed the old stores?

Perhaps there is another explanation. On February 29, 1960, a young black man by the name of Clarence Fort walked into Woolworth's and took a seat at the lunch counter. Fort was the president of the local NAACP Youth Council, and he was taking a very brave action at that moment, as segregation was still rampant in Tampa at the time. He and his friends were not allowed to order at the counter. Instead, the managers simply put up a sign stating that the counter was closed. Of course, it opened again as soon as the young men left. But they didn't give up. Day after day, at Woolworth's and other lunch counters and soda fountains, dozens of African American young people would sit down. White customers would immediately get up and leave, and the mangers would put up a "closed" sign. Fort would later say, "You could spend a thousand dollars in the store, but you could not go over and get a hamburger, coke or hotdog. If you did, you had to get it to go or stand up at the end of the counter. That was it. You could not sit down."

After a week, Julian B. Lane, the mayor at the time, appointed a special commission to start integrating the lunch counters. Within six months, segregation was ended at the five-and-dimes.

It should be noted that there was no violence associated with this transition and that most of the participants in the drama are still alive. Yet there is an energy that remains in the old buildings, left over from a time of fear and intolerance.

The Old Federal Courthouse

If you stroll along Florida Avenue from the First Methodist Church, past the Hotel Floridan to the Old Federal Courthouse, you may just see an elderly man, impeccably dressed in a crisp, white-linen suit and wearing a flat-topped straw hat, called a boater. Look more closely, and you may notice a jagged red slash across his neck, from ear to ear. If you should see such a specter, turn and walk away, for you have just seen the ghost of Charlie Wall.

That name has appeared on previous pages, as someone buried at Oaklawn Cemetery and someone who used to enjoy a drink at the old Sapphire Room in the Hotel Floridan.

The old Tampa Federal Courthouse, with the Floridan Hotel in the background. *Courtesy of the Tampa-Hillsborough Public Library System.*

Charles was born in 1880. He was the son of John P. Wall (remember the doctor who correctly surmised that yellow fever was spread by mosquitoes?) and Matilda McKay, a member of one of the richest families in Florida. One would think that Charlie would have had a childhood with all of the advantages that money and social position could buy. But things began to go very badly for Charles when he reached his teenage years. In 1893, his mother passed away. It was less than six months later that Dr. John married his housekeeper, Louise Williams. Charlie hated his stepmother. He would later say that she was a cruel woman who spent his father's money too freely. Things went from bad to worse when John himself died in 1895, leaving the custody of his young son in the hands of the "wicked stepmother." Louise's spending habits became even worse without the steadying influence of John, and Charlie grew to dislike her more and more. He began spending more and more time away from home, often in bad company, at the saloons, brothels and gambling

parlors. Things finally came to a head when he shot his stepmother with a twenty-two-caliber rifle. "I was just tired of her," he later explained. Despite being wounded, Louise did survive. But as you can imagine, she wanted nothing to do with her wayward stepson.

After a short stay in juvenile detention, Charlie was packed off to Birmingham Military School in North Carolina. He didn't stay there long, as he was quickly expelled. He would later claim that he had been gambling and hanging around in brothels and was thrown out for this flaunting of the rules. However, school records indicate that he was expelled for the more mundane transgression of cheating on a test. For whatever reason, his military career was over. He returned to Tampa, but he did not go back to the stepmother he hated (and it was doubtful that she wanted him back anyway after being shot). Instead, he began living on the streets of Ybor City and learning the ways of the criminal element. He was dealing craps in illegal casinos in the red-light district before he reached his sixteenth birthday. He was a very successful gambler himself because he was a mathematical whiz bordering on genius.

In the early twentieth century, Charlie used his knowledge of mathematical probabilities to take over the numbers racket in Ybor City. Known as "bolita" or "little ball," it was a very popular (although illegal) lottery-style game. Much like today's perfectly legal Powerball lottery game, bolita involved placing bets on which numbers would be drawn from a large group of balls. In the case of bolita, numbers from one to one hundred were written on small balls made of wood or ivory. The balls were then drawn from cloth bags. With his skill at numbers, Charlie was perfectly capable of making a profit on a totally honest game. However, he was not above "rigging" the odds when it suited him. Sometimes, he would put lead weights in the balls carrying numbers he did not want to be drawn. These balls would then sink to the bottom of the bolita bag and be much less likely to be pulled out. Also, if there was a number he wanted to be drawn, Charlie would have that ball frozen. It was easy to pull a "cold one" out of the bag. Charlie would remain in control of bolita for the next twenty-five years.

With his profits, Charlie branched out into other traditional areas of organized crime: drugs, prostitution and, during Prohibition, illegal alcohol. Ironically, his upper-class background helped him in many ways. As a son of both the prominent Wall family and the wealthy McKay family, doors were open to him that were not open to the average hoodlum. He could go to country clubs, fine restaurants and homes of the wealthy. And even the influential and wealthy loved to play bolita. He also knew how to dress

and act the part. He dressed like a gentleman, in a white-linen suit, and his manner was described as polite and soft-spoken.

In 1910, Charlie consolidated his power with the working class of Tampa and Ybor by supporting the cigar workers' strike. This was more than lip service on his part, as he paid medical and food bills for those who were struggling. And although the strike was not successful, those workers never forgot Charlie Wall. He became their hero. They supported him, and more importantly, they voted the way he wanted them to vote. This helped Charlie gain control of the politicians, judges and city leaders throughout the 1910s, '20s and '30s. Not only did officials leave Charlie's operations alone, but if someone else set himself up as a potential rival, his operations were quickly raided by the police, who were firmly in Charlie's pocket. Charlie was Tampa's version of a "Teflon Don." Although he was brought to trial on a few occasions, he was always acquitted. Rivals who were being squeezed out of their "piece of the pie" tried to have him assassinated, but he always survived.

On one memorable occasion, Charlie was facing certain death, as two hit men had his car pinned in. His driver, "Baby Joe," who also often served as a bodyguard, stood on the car's running board. While still driving with one hand and firing his gun with the other, Charlie maneuvered the car backward through traffic. Neither Joe nor Charlie had so much as a scratch.

Charlie was often asked how he escaped so many attempts on his life. His reply was, "The Devil looks after his own."

As the 1930s wore on, Charlie began to tire of his dangerously exciting life. By 1940, he retired and moved to Miami, leaving a blood bath behind, as other racketeers tried to grab a hunk of Charlie's power.

That could have been the end of the story, but something happened in 1950 that changed everything. That year, Tennessee senator Estes Kefauver, who had aspirations of becoming president, saw the issue of organized crime as his ticket to the White House. On May 3, he became head of the Special Committee to Investigate Crime in Interstate Commerce. This committee held hearings in fourteen major cities across the United States, including Tampa. Many prominent gangland figures were called to testify. All of them denied any connection with organized crime—all, that is, except Charlie Wall, who returned from Miami to testify. To use gangster vernacular, Charlie "sang like a canary." He gave details, told secrets and named names. Accounts of the time say that he captivated the whole city with his dry wit and intriguing tales. The

hearings played on live television throughout the country, and Charlie became a celebrity.

Enjoying his renewed fame in the city of his birth, Charlie moved back to Tampa, where he continued to entertain and thrill with his stories of his life of crime. This was not very smart. Many of those in power were not happy about either Charlie's testimony at the hearings or his return to Tampa. Even though he had no real power anymore, he was seen as a threat. He was warned by his friends to keep quiet and lay low. But it appears he was just having too much fun with his notoriety, and once again, he survived several attempts at his life. Apparently, the Devil was still looking after his own.

But on an April night in 1955, the Devil must have had better things to do. It appears that Charlie had opened the door for someone he knew and trusted, as there was no forced entry into his home. His wife, who had been out of town, found his body the next morning. He was wearing his pajamas and a dressing gown. He had been beaten about the head with a sock filled with birdseed, which actually makes a formidable weapon and is a traditional mark of disrespect for someone who "sang" to the authorities. The assailants also used a baseball bat, and Charlie's throat had been slit from ear to ear. On the nightstand next to Charlie's bed was a copy of *Crime in America* by Estes Kefauver. Had Charlie been reading it before he opened the door to his attackers? Or did the perpetrators leave it there as a warning to any others who might be tempted to "sing"?

Who murdered Charlie Wall? To this day, no one knows. The police did have a few suspects, but the murder remains unsolved. And an unsolved murder seems one of the primary causes for a haunting.

And Charlie does still seem to find his old "haunts." His white-suited figure has been seen in Oaklawn Cemetery, in the Sapphire Room and on the street in between. But his ghost is most closely associated with the Old Federal Courthouse, just a bit farther down Florida Avenue—perhaps because it was in that building that the Kefauver hearings were held, and that is where he first told the stories that ultimately led to his death.

Passersby who have photographed the steps of the courthouse after nightfall have seen strange things in their images. Bright orange lights appeared in the transoms of the huge glass doors on the main level. Misty faces have been seen in the windows of the upper stories. The most eerie of all was an image of a figure in white mist that seemed to be descending the staircase. Perhaps this is the most appropriate of all, since one of Charlie's

nicknames during his reign as the king of Tampa's underworld was the "White Shadow."

The Old Federal Courthouse was completed in 1905 and is the oldest government building standing in Tampa. It was placed on the National Register of Historic Places in 1974, but it closed in 1998 when all activity moved to the new Sam M. Gibbons Courthouse a few blocks away. Between that time and January 2012, you could have a ninety-nine-year lease on this building for the sum of $1. Of course, you also had to prove that you had at least $17 million to restore it.

Currently, Tampa Hotel Partners LLC has plans to develop the ninety-thousand-square-foot building as a luxury hotel. The estimated cost of the project is $25 million. The courthouse is well suited to the project, with its beautiful marble floors and high ceilings. Perhaps some of the old courtrooms can be turned into meeting rooms or even a lounge. Presently, the new Le Meridien Hotel is slated to open sometime in 2015, and when it does, perhaps old Charlie Wall will be there to greet the guests, still wearing his white suit and boater hat. And, of course, he will have that "extra smile" slashed across his neck from ear to ear.

The Tampa Police Memorial

At 411 Franklin Street stands a building of blue glass and steel. Large, yellow neon letters proclaim, "Tampa Police." Right at the corner facing Franklin is a large obelisk of polished granite with the carved-out silhouette of a uniformed police officer. There is also a reproduction of an officer's badge, covered with a black band. And a bronze replica of a policeman's cap, a gun and holster, a nightstick and a badge sit forlornly on a small shelf. Behind the silhouette are the words, "Lost in the line of duty, united in honor."

Built in 1997, this structure is a memorial to Tampa police officers who have lost their lives during the performance of their duties from 1895 to today. There are thirty-one names inscribed. Officer John McCormick is the first. On September 26, 1895, he and Officer Howard Bishop, "a negro officer," responded to a report of an altercation in front of Salter's Bar in the "Scrub," which was the African American section of Tampa at the time. The officers broke up a fight between two women, Ella Felter and Lula Williams. They apparently determined that Ella Felter had started the fight and were in the process of placing her under arrest when Harry Singleton,

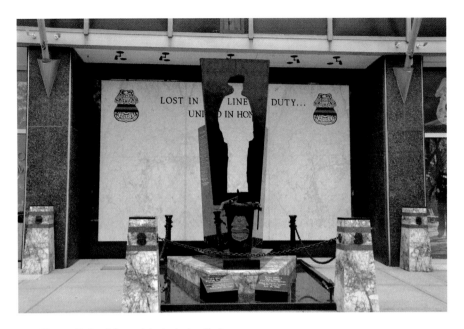

The Tampa Police Memorial. *Author's collection.*

Ella's boyfriend, came out of the bar and shot McCormick at point-blank range. The officer died almost immediately.

Mass confusion ensued. Officer Bishop attempted to fire at Singleton but missed, striking a nearby horse instead. Singleton and his girlfriend escaped. A vigilante posse of about forty men was immediately formed. The men took rope with them in their manhunt, and there would have undoubtedly been a lynching if Singleton had been found. But the search proved fruitless. Seven days later, Singleton was found in Ybor City and arrested without further incident. By that time, tempers had cooled enough, and arresting officers seemed determined to protect their suspect. No lynching took place, but the outcome was the same. A trial was held, and Singleton was found guilty and sentenced to hang. That sentence was carried out on January 8, 1898.

Officer John McCormick was laid to rest in Oaklawn Cemetery. By 1995, his gravestone had deteriorated so badly that a new one was put up on the 100th anniversary of his death. To this day, it is easy to locate within the walls of Oaklawn.

It would be ten years before another officer died in the line of duty. But the list goes on. The pace of deaths picks up in the 1930s and early '40s,

slows in the '50s and '60s and then accelerates dramatically in the '70s. Since then, the pace has stayed relatively the same.

The last two names on the memorial are officers who were killed on the same day, June 29, 2010. We know the details of their deaths because it was captured on the "dash cam" of one of the officer's cruisers. On that fateful evening, Officer David Curtis made what appeared to be a routine traffic stop of a vehicle, a red Toyota, without a license plate. He questioned the driver, Courtnee Brantley, and a passenger, Dantae Morris. He returned to his cruiser, probably checking for warrants. A few minutes later, Officer Jeffery Kocab arrived as backup. The two officers told Morris to exit the car, stand beside it and place his hands behind his back. At first, Morris seemed willing to comply, but suddenly, without any warning, he pulled out an oversized handgun and shot both officers in the head, first Officer Kocab and then Officer Curtis. The dash-cam video then shows the red Toyota pulling away, running over one of the officer's legs as the suspects fled the scene. One of the most massive manhunts in Tampa's history followed, and a $100,000 reward was offered. Morris turned himself in within a few days. Before the end of the day, he was a suspect in three additional murders.

Although Morris's trial for the killing of Curtis and Kocab is not scheduled to begin until November 2013, he has already been sentenced to life in prison for another murder, that of Rodney Jones outside of a nightclub in 2010. He faces the possibility of the death penalty for the murder of the officers.

There have been no sightings of ghosts at the Memorial Wall. However, ghost-hunting equipment always registers high activity in the area. And the poem for the memorial, written by retired policeman George Hahn, seems to speak as if it were a voice from beyond the grave:

> *I never dreamed it would be me,*
> *my name for all eternity, recorded*
> *here at the hallowed place, alas,*
> *my name, no more my face.*
>
> *"In the line of duty," I hear them say*
> *my family now the price to pay*
> *my folded flag stained with their tears*
> *we only had those few short years.*
>
> *The badge no longer on my chest,*
> *I sleep now in eternal rest, my sword*

I pass to those behind, and pray that they
keep this thought in mind.
I never dreamed it would be me,
and with heavy heart and bended knee,
I ask for all here from the past;
Dear God, let my name be the last.

On special occasions, there is a dramatic addition to the memorial, as a single streak of blue light emanates from a small window above the silhouette. This laser-generated "thin blue line" soars over the park and into the night sky, ending on the BB&T bank building over a block away. The light represents law enforcement as a line separating good from evil and protecting the good citizens of Tampa. This light was added in 2011, and it is there to honor all the men and women who "protect and serve," including those who have fallen in the line of duty. Perhaps the spirits of those fallen come to visit the memorial. Hopefully, they are pleased with the remembrance.

The Mad Russian

Tampa has always attracted its share of colorful characters. Some are quite benign, but others are quite sinister. Sometimes, they are a little of both.

Dr. Frederick N. Weightnovel came to the Tampa area from Russia. Was Weightnovel his real name? Was he even a doctor? The answers are uncertain, although we do know that he applied for membership in the Hillsboro County Medical Association. And we do know that his request was denied.

Born in Russia, Weightnovel claimed to have been imprisoned by the tsar for advocating a violent overthrow of the Russian monarchy. He said that he managed to escape Siberia by swimming across an icy river. A tall and heavyset fellow with a huge barrel chest, he let his hair and beard grow long. In fact, he claimed that he had vowed that if he ever escaped Siberia, he would never cut his hair or beard again. All this gave him an appearance that earned him the nickname of "The Mad Russian," a Tampa version of Rasputin.

Moving into a building on Whiting Street between Franklin and Tampa Streets, Weightnovel developed a thriving business in "patent medicines."

Downtown

This building at the corner of Franklin and Whiting may have been the place where Dr. Weightnovel had his practice. *Courtesy of the Tampa-Hillsborough Public Library System.*

Today, we might call him a "snake-oil salesman." He sold tonics that he claimed had highly beneficial effects for both men and women. Among other things, he claimed that his tonics would "restore manhood." (Was this the nineteenth-century version of Viagra?) His marketing techniques were unorthodox, to say the least. He would head down to Tampa Bay on warm afternoons and simply float on his back for hours—eating his dinner from a silver tray balanced on his ponderous belly, reading the newspaper or smoking a cigar. When a crowd would gather to watch him, he would take the opportunity to promote his restorative products. He was also one of the first people to use a business card, as he had cards made with his picture, complete with long, wild, gray hair and shaggy beard. The card was printed in both English and Spanish and claimed that he was an 1863 graduate of the Russian Imperial Moscow University. Of course, in those days, that kind of claim would have been difficult to verify.

But Weightnovel did have his fans. A wealthy woman named Julia Daniels Moseley, who had spent a few months in Florida, hired him to be her personal physician, and she adored him. She wrote in a letter to her sister in the North, "He is very odd, very smart and has wandered nearly all over the world. He is a scholar, something of a writer and a lover of nature." But Weightnovel had his detractors as well—and he had his share of legal difficulties. His first problems with the law came in 1883. At this time, the abandonment of Fort Brooke had left the area open to homesteaders. Weightnovel recruited a group of followers who attempted to found their own town on the abandoned property. It was intended to be a utopian, socialist community. Weightnovel went so far as to appoint himself the mayor of the new town, which they named Moscow. However, Tampa authorities were not amused by this upstart town within their own borders, and the local police broke up the commune, evicting the members from the property.

The second brush with the law had more serious consequences, although it is amusing by today's standards. Sometime around 1883, Dr. Weightnovel, ever the radical, decided that Tampa needed a "Free Love Society." He became the club's founder and president. One fine evening, the members, including about thirty of the most eligible bachelors in the area, got together, dressed in handsome pseudo-military attire and rode on horseback to the Old Habana Hotel in Ybor City. There they had a sumptuous banquet, served by lovely African American woman who were totally naked. Several courses of food were served, many of them with aphrodisiac properties. However, no one bothered to close the curtains. The citizens, even the more disreputable folks of Ybor City, were appalled. Weightnovel and all his cronies were hauled off to jail. Although he was there only for a few days, he said that Tampa jails were horrible, worse than being imprisoned in Siberia. He vowed to never spend any time in jail again.

In 1903, Weightnovel would be involved in another scrape with the law. As far as Tampa was concerned, it was the trial of the century. Of course, there were ninety-seven years to go.

It seems that the "doctor" had begun to branch out in the services he offered. Besides patent medicines, he had begun to run a "health clinic" on the second floor of his building. One of the services he offered was to "help" women who found themselves with an unwanted pregnancy. Dr. Weightnovel began to perform abortions, and not just for the local women of the streets. He offered his services to the wealthy and elite of Tampa as well. The trial in question concerned the death of a young woman by the name of Irene Randall. She had come to see Weightnovel in 1902, seeking

to end a pregnancy. Something must have gone terribly wrong, for after the procedure, she developed a raging infection. Believing that she was dying, Irene begged Dr. Weightnovel to send for her mother. She wanted to see her one last time. He promised he would send for the woman, but he never did. In her few lucid moments, Irene would go to the window of her room and gaze out at the street, hoping to see her mother, who, of course, never came.

After about a week, Weightnovel became concerned enough to summon a real physician to consult on the case. He called on Dr. B.G. Abernathy, an actual member of the Hillsboro County Medical Association, to come to examine Irene. Of course, he did not tell Abernathy the full truth about what had happened. He claimed that when Irene came to see him, she had already taken "strong medicine" that had caused a miscarriage. However, when Dr. Abernathy spoke to Irene, she told him the truth about what had happened. She also told him how Weightnovel had promised to contact her mother but that she was sure he had never done so. Abernathy was unable to do anything to help the girl, and she passed from this life to the next. Or did she?

Frederick Weightnovel was brought to trial for manslaughter. The testimony included a particularly brutal description of the operation performed on Irene. Dr. Abernathy was the star witness, describing the desperate state of the young woman by the time he had been called in. "She told me that she was dying and wanted to send a message to her mother," he said, "and that Dr. Weightnovel had promised her that he would telegraph her mother but had not done so."

After a four-day trial, Weightnovel was found guilty. He appealed his case to the Florida Supreme Court, but he lost there as well. He was sentenced to serve a six-year term in prison at hard labor, which actually seems like a light sentence considering the severity of his crime. However, even one day in jail was more than he wanted to face. Weightnovel poisoned himself, perhaps by drinking too much of his own patent medicines, so that he wouldn't have to serve time.

On the corner of Franklin and Whiting Streets, there is a two-story brick building that we know was standing in 1902. Is it possible that this is the building where Irene Randall met her death at the hands of the Mad Russian? It is the only building of that era still standing at that corner. Much time has passed, but apparently the two spirits are still restless. The second-story windows are tall and narrow. Late at night, a figure is sometimes seen in the second window from the front of the building. The figure is indistinct, almost as if it is made of a white mist. But it is the shadowy figure of a

young woman. She appears to be dressed in an old-fashioned nightdress, with a high-ruffled neckline and long sleeves. She gazes out over Whiting Street as if searching for someone and then appears to back away from the window and vanish into the darkness. Even when there is no figure, orbs of light appear in photographs of the building. And many have complained of an uneasy feeling as they gaze up at the window. Could this be the spirit of Irene, still waiting for her mother after all these years? If it is, she is not the only spirit that haunts this dimly lit corner. The figure of a tall and portly man with long hair and a beard seems to float past the windows on the first floor. The space is currently occupied by a law firm. A local attorney who does business with that firm says that she and her colleagues refuse to have business meetings in those offices. "It is just too creepy," she said.

Old Tampa City Hall and a Clock Named Hortense

After all its many ups and downs over the years, Tampa was feeling pretty good about itself in 1915. For thirty years, the town had grown at an astounding rate, largely due to the growing phosphate and cigar-making industries. The 1880 census showed 720 people, while the 1910 census indicated 37,782 people living in Tampa at the time. It seemed like the perfect time to build a new city hall, and architect M. Leo Elliot was hired to design a building in the Eclectic style. The design featured Doric columns, a balustrade and terra-cotta details. The main section of the building is decorated with faces that might look Greek but were actually modeled on a Seminole girl with long braids. A seven-story tower rises above that main section, and a bell clock system resides within the top two stories. In 1972, the *Tampa Tribune* described the structure as "Tampa's City Hall Layer Cake." It was the tallest building in the city until the Tampa Theatre Building and the Hotel Floridan were built in 1926.

Completed in late 1915, the building cost $235,000 and included an annex to serve as a police station and jailhouse. Although the annex is now gone, torn down in the 1960s due to dangerous deterioration, the main building still stands, and it remains in use as city offices to this day, although the main city offices, including the mayor's office, are held in a more modern building a few blocks away. However, there is one aspect of the historic building that remains unchanged: the bell continues to chime out the hour (with one "bong" on the half hour) to this day. And it almost never happened.

Downtown

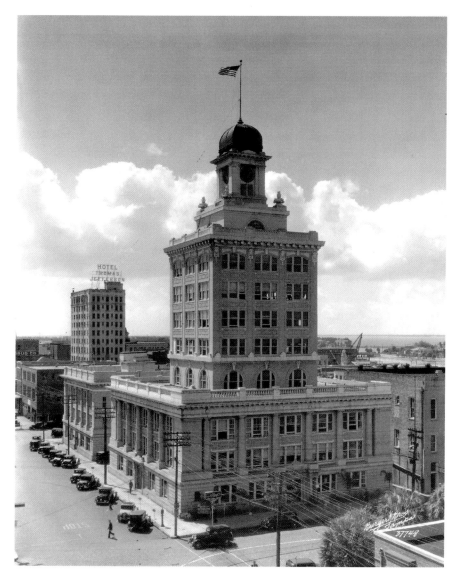

Tampa's Old City Hall. *Courtesy of the Tampa-Hillsborough Public Library System.*

Back in 1914, there was a prominent physician named Louis Sims Oppenheimer living in Tampa. He had five daughters, all lovely young socialites. One of those daughters, Hortense, was extremely upset that the new city hall would not have a clock in its tower. It seems that Tampa had decided that it was too poor to buy a clock.

Hortense sprang into action. She formed an organization called Ye Town Criers to raise the money. The group sponsored various events, mainly entertainments such as musicals and theatricals, with the profits going toward the purchase of the timepiece. Despite its best efforts, the group could manage to raise only $1,200. But the W.H. Beckwith Jewelry Company jumped in to donate the balance, as well as construct the actual 2,840-pound, four-faced clock. Upon completion and dedication, the clock was named in honor of the girl who had worked so hard to make it happen. Even now, the clock is known as "Hortense the Beautiful."

By 2012, the nearly one-hundred-year-old clock had seen better days. The copper roof of the tower was leaking badly, damaged columns needed rebuilding, the four metal clock faces needed refinishing and the clock's eight hands and white-film glass needed replacing. Tony Kavouklis, a general contractor, was hired to oversee the refurbishment. "This isn't your average trip to the hardware store," he quipped. The project cost $585,000—more than double the cost of the entire original building. In addition to being expensive, the job was difficult. Original plans had been lost, so old photographs were used to ensure the accuracy of the restoration. The job started in late May 2012 and was completed just in time for the Republican National Convention, which was held in Tampa in August of that year.

During the restoration, workmen described the sensation of being watched. When they would turn to look over their shoulders, they would see the slender figure of a girl in her late teens with light brown hair in waves around her face. She was dressed in a white dress with ruffles on the sleeves in the style of the early twentieth century. She would smile at the workers and nod her head, as if in approval, and then vanish right in front of their eyes. Was this the original "Hortense the Beautiful" for whom the clock is named? Was she checking the progress of the restoration of her beloved timepiece and showing her approval before disappearing? And if it was Hortense, does her spirit still stop by the clock even now that the workmen are gone? One can only hope that she is pleased that the clock still works and still bears her name.

Hortense is not the only ghost within this graceful old building. Some of the illustrious mayors of Tampa, long dead, appear from time to time on the building's central staircase. Donald Brenham "D.B." McKay was mayor when the building was completed. A member of one of Tampa's most important families, he was born in 1868 and got his first job as an apprentice printer at the *Tampa Tribune* at the age of fourteen. Within

seven years, he had purchased the paper, and he served as its chief editor for the next forty years, including the time he was serving as mayor. He was first elected in 1910 and was reelected in 1912 and 1916, serving until 1920. In 1927, he decided to run for another term as mayor and was elected by a landslide, serving until 1931. There was good reason for his popularity. McKay was a charismatic, dynamic leader who worked tirelessly for the betterment of the city.

During his first three terms, from 1910 to 1920, Mayor McKay made sure that streets and sidewalks were paved and that adequate sewer systems were put in place. Under his leadership, brick fire stations, the first public library, the Lafayette Street Bridge (now Kennedy Boulevard) and, of course, city hall were constructed. For the length of his long life, he continued to pile up accomplishments and honors. He served on President Wilson's Advisory Committee for the Southwest during the Great War. He was a director of the First National Bank and a founding trustee of the University of Tampa. In 1949, he became the official historian of Hillsborough County, and he began writing a history column for the *Tampa Tribune* in 1950, when he was already in his eighties. He died in 1960 at the age of ninety-two. The cause of death is listed as heart failure. He is buried in Myrtle Hill Memorial Park in Tampa.

To this day, Mayor McKay's tireless energy seems to permeate the grand old building that he was so instrumental in having constructed. A ball of light has been reported zipping along the corridors and has also been seen in the clock tower at night. Could this be Mayor McKay, the man who was both the thirty-eighth and forty-second mayor of Tampa, still keeping watch over the city he loved?

Another important mayor of Tampa was Curtis Hixson, who served from 1943 to 1956. Unlike Mayor McKay, Hixson was not a member of an old Tampa family. Born in Alabama in 1891, he moved to Tampa in 1914 to become a pharmacist. After serving in World War I, he returned to Tampa and purchased King's Drugstore on Franklin Street. He was always interested in politics, and he began his career by serving on the Tampa City Council from 1929 through 1937. In 1939, he was elected to the Hillsborough County Commission. When he was elected mayor in 1943, he defeated Robert E. Lee Chancey, a three-term incumbent.

Serving as mayor during World War II certainly had its challenges, such as the rationing of sugar, gas and meat. But the city also benefited from federal defense contracts. Hixson saw the city through these turbulent times

and into an era of prosperity. He was a very visible and active mayor, often appearing in public. Hixson died in office. Hospitalized for pneumonia on May 11, 1956, he passed away on May 21 of heart failure.

Naturally, having been mayor for so long, Hixson's face was one of the most recognized about town. His receding hairline, lopsided smile and slightly protuberant ears continued to be seen in mirrors and windows around Old City Hall for years after his death. Oddly enough, the sightings stopped in 1964. That was the year a convention center was built between Ashley Street and the Hillsborough River. It was named Curtis Hixson Hall. The sightings returned when Hixson Hall was torn down in 1993. Could it be that his spirit became restless again when he felt slighted?

The spot where Hixson Hall once stood is now a city park, Curtis Hixson Park. Apparently, a park is not enough to satisfy the spirit of the former mayor.

The Old Tampa Book Company

The bookstore at 315 East Kennedy Boulevard is well named. You will find no new books here, although some are certainly older than others. When David and Ellen Brown opened the store in 1995, they had two thousand books. Pretty impressive. But now they have over forty thousand, filling the shelves from floor to ceiling and spilling out onto the sidewalk on "dollar-a-book" rolling carts. They feel very lucky to be able to follow their passion for books every day. The Browns specialize in rare and out-of-print books centering on multitudinous subjects such as history, the arts, biographies and children's literature. There are many limited-edition books, with several bearing the signature of the author. There is even one signed by Groucho Marx. If you can't find it here, you may not find it anywhere.

For several years before David and Ellen opened their store, the property sat unused. Not empty, just unused. It was filled with things left behind when, nearly twenty years before, a tailor by the name of Richard Bennet had decided to retire. According to David, "The guy just turned out the lights and locked the doors." He left everything behind, and it simply sat, gathering dust.

Despite the mess inside, the Browns thought the space was perfect for their needs. So they worked out a deal with the landlords. They would clean up the mess and get rid of all the stuff in exchange for two months of free rent. It turned out even better than they anticipated, as they found several

things that they could use. Among the items they kept were a couple of little low chairs. The chairs look as if they are suited for children to use, but they were actually for Mr. Bennet to sit on while doing a hem. Now they provide comfort for customers browsing books on lower shelves. The Browns also repurposed some coat racks as bookshelves, and they kept a large pair of scissors. After all, scissors should be handy in a bookstore. They keep them on a hook by the desk.

However, on some mornings, those little chairs are not where they were placed the night before. Have they moved by themselves? Is an unseen spirit hand at work? Does Richard Bennet still watch over his old shop?

Several years ago, the store's motion-sensitive alarm went off in the middle of the night. The police responded but found everything to be normal. The front door was securely locked and the usual lights were on inside; nothing appeared to have been disturbed. Assuming that it was a false alarm, they did not investigate any further. When Ellen arrived the next morning, everything at first looked normal to her as well. The books all remained on the shelves, and nothing was missing. However, she could not find the scissors. She was fairly certain she had left them on the hook the night before, but they were not there. She began to search, finally finding them on the floor. She bent to pick them up but quickly recoiled. The blades of those scissors were covered with blood, and a blood trail led from where they lay on the floor into the back room and right out of a hole in the wall that had apparently been made by a would-be thief. There the trail ended, as if whoever was bleeding had jumped into a car and driven from the scene.

Was the robber interrupted? Is that why nothing was taken? Did the spirit of the old tailor, still protecting his shop, grab those scissors and take after the intruder, getting in at least one good whack? It makes sense that if the spirit of Richard Bennet is there, he would reach for the only weapon in the store that had belonged to him—the only weapon with which he was familiar. Although Ellen and David are reluctant to believe that this was a paranormal occurrence, the mystery remains unsolved to this day.

There are many who say that a ghost cannot physically harm you. They might frighten you into doing something stupid, but they cannot actually hurt you themselves. Perhaps this story proves that if the provocation is strong enough, a spirit can do what a spirit has to do!

The Sykes Building

The downtown Tampa ghost tour walks right by the Sykes building at 400 North Ashley, but it isn't usually a stop. However, one night, a guest halted directly in front of it. "I'm a psychic," she said, "and there are two ghosts inside this building. They are angry that you are not telling their stories on your tour." Unfortunately, she couldn't elaborate on just what those stories were.

Completed in 1988, this icon of Tampa's skyline is certainly unique. A round tower rising 454 feet and thirty-one stories, its official name is Rivergate Tower. But no one calls it that. In fact, it is most commonly referred to as the "Beer Can Building" because of its shape. The major tenant is Sykes Enterprises, a provider of customer services, and the word "Sykes" is emblazoned in large red neon letters on the side of the tower. Is the building haunted as this person contends? And if so, who might the ghosts be?

The Sykes "Beer Can Building." *Author's collection.*

When Rivergate Tower was first built, it was beautifully landscaped by world-famous American landscape architect Dan Kiley. Both the building and the four-and-a-half-acre plaza garden were based on the famed Fibonacci mathematical sequence. The landscaping is actually on top of a two-story underground parking structure. Over the years, the crepe myrtles and other plantings that were so important to Kiley's design sent their roots down into that structure. So in 2006, most of the landscaping was torn out. The garden looks absolutely nothing like Kiley intended it to. The website TakeMyTrip.com notes that the place "looks more like a graveyard than a park" and also describes it as an "eerie oasis." Dan Kiley passed away in 2004, two years before the destruction of his work. Could he be one of those spirits who is angry that his story is not being told?

Who is the other spirit? It could be a very old one, perhaps one of the Tocobaga or an early pioneer, for the spirit seems to have been around from the very earliest days of the building. Carl Harris was quite a young man when the "Beer Can" was completed. His first job out of high school was to set up offices in the brand-new Rivergate Tower. He recalls an eerie feeling and unexplained cold spots in several of the rooms, particularly those on the higher floors. When he was working alone late at night, he would feel as if someone was watching him.

Today, the building is a busy place, and during the day, no one seems to have any problems with spirits. But at night, it seems, there are spirits that want their stories to be told.

The Scrub and the Jackson House

The "Scrub" was the name given to Tampa's African American section for many years. Founded by former slaves in the early 1800s, it was considered a less desirable area than the area where the white population lived, closer to Fort Brooke. Over the years, the Scrub grew into a thriving community that was home to around twenty-one thousand African Americans. But by the 1960s, it had deteriorated into a pretty rough area and was torn down for urban renewal. Little of it remains today.

However, one building does still stand on the edge of what was once the Scrub, at 851 Zack Street. This is the Jackson House. In 1901, Moses and Sarah Jackson built a six-room cottage here, but they began adding on almost immediately. They wanted the extra rooms for income, and what had started as a family home quickly became a boardinghouse. Soon, there was a second story, as well as several additions off the back. It operated as a rooming house until 1989.

In its prime, the boardinghouse was very successful because it was within walking distance of the Union Train Station, making it easy to locate and get to. It was also one of the few places where an African American person could stay in segregated Tampa, and many well-known people passed through its doors, including Count Basie, Cab Calloway, James Brown, Ella Fitzgerald and Ray Charles, just to name a few. Although they came to town to perform, they were not allowed to stay in the "whites-only" hotels downtown. Dr. Martin Luther King Jr. also stayed there when he came to preach at St. Paul's AME Church.

The Jackson House boardinghouse on Zack Street. *Author's collection.*

Today, the building at 851 Zack Street just looks like a haunted house. The roof sags, and several windows have broken glass and crooked frames. Most of it sits empty and forlorn, but faces composed of mist have been seen in those windows. And the sweet sounds of jazz and blues music have been heard coming from the empty rooms. It seems as if those performers who stayed here long ago are continuing to perform to this day.

Even though the Jackson House was added to the National Register of Historic Places in 2007, its future is far from secure. It sits alone on a block filled with parking lots. The current owner, Willie Johnson, who lives alone in the house now, is doing his best to keep up the property, but it is in sad shape and getting worse. We can only hope that it will be preserved. After all, where would all those spirits go?

Part IV
Across the River

The Falk Theatre

The Hillsborough River was named for an English gentleman, the Earl of Hillsborough, who was governor of "West Florida" during its years as an English territory. The river begins in an area known as the "Green Swamp" and runs fifty-nine miles southwest before emptying into Tampa Bay. Today, the river runs along the edge of downtown Tampa, and a trip across the Kennedy Boulevard Bridge will bring you to two of the most haunted places in the Tampa area.

The Park Theatre was built in 1926, the same year as the Tampa Theatre, but it was built for an entirely different purpose: it housed live performances, not movies. It was a vaudeville house. Although most young people today are unfamiliar with the word "vaudeville," it was tremendously popular in its day. This theatrical genre consisted of acts that were repeated in the same order, two or three times a day. You could pay your admission, usually not more than ten or fifteen cents, and have a full day of entertainment. There were acrobats, jugglers, singers and comics. In fact, many early television comedians, including Jack Benny, George Burns and Gracie Allen, got their start on the vaudeville stage.

The building is now the property of the University of Tampa and is known as the Falk Theatre. Mr. David Falk was a local businessman who

The Park Theatre, now known as the Falk. *Courtesy of the Tampa-Hillsborough Public Library System.*

served on the university's board of trustees from 1948 until his death in 1960. The building was renovated by the university in 1981 and now hosts plays, choir concerts, dance recitals and other live events. But the theater is apparently still home for one of the old vaudeville performers.

Her name was Bessie Snavely. She may be simply a legend. But if so, it is a very persistent legend indeed.

Her story begins happily enough. Bessie was a singer, very popular with the crowds and much in demand at the old Park vaudeville house in the 1930s. She would appear on stage wearing a floor-length red gown. She fell deeply in love with one of the theater's stage managers, and he returned her affection—at least at first. Unfortunately, he proved to have a wandering eye, and one afternoon, Bessie arrived at the theater ahead of schedule and found her love in an indelicate position with one of the other female performers. Distraught, Bessie ran home to retrieve her pistol, with the intention of shooting her unfaithful lover and his

paramour. But by the time she returned to the Park Theatre, her anger had turned to despair. She decided to end her own life instead.

One version of the legend suggests that Bessie hanged herself in her dressing room. But the more prevalent version is that she climbed up to the flies above the stage, fashioned a noose from a rope from one of the stage curtains, put the noose around her neck, tied the other end to the catwalk railing and then jumped during a performance of one of the other acts. Her now-lifeless body was hanging and swinging back and forth in full view of the audience. At first, the onlookers assumed that it was part of the act on stage and laughed. But amusement turned to horror as they realized the truth—that a woman had taken her own life in front of their eyes.

It seems that Bessie still "hangs around" the old theater. The misty figure of a woman floats on the landing and the staircase near the dressing rooms. Sometimes, just before a performance, the sound of a woman sobbing will echo through the wings and backstage area. Doors have been known to open and then slam shut in quick succession without any visible means. Set builders have reported power tools going on and off by themselves. One stagehand claimed that an unseen steadying hand saved him from a fatal fall from the catwalk in the flies. And many have caught glimpses of a figure in a long red dress throughout the theater.

In most ways, Bessie's spirit seems quite benign. But there is one thing that brings out her more threatening side. Apparently, she still feels that the color red is her trademark. Red costumes have been known to disappear from racks, only to be found again in unusual places or never found at all. And it is not just women's costumes. One young man was given a red smoking jacket to wear in one of the university's live theater productions. It disappeared after the preview performance and could not be located. Another jacket had to be used for opening night and the rest of the performances. On one occasion, an actress was given a 1930s-style floor-length red evening gown as a costume. This must have infuriated Bessie as being too close to what she once wore, because the day after the first dress rehearsal, the red gown was found in the middle of the stage, torn to shreds!

Costumers at the Falk have simply learned to avoid the color red.

Theater students at the university have developed a ritual to keep Bessie's spirit appeased. After every opening night, they place a copy of the playbill for the show and a single long-stemmed red rose in the center of the stage, right under the spot where Bessie's body would have swung. When they return the next night for the second performance, the playbill remains on the stage, but it looks as if it has been read, as if someone had picked it up

There are at least two other theaters in the Tampa area that have the reputation of being haunted. One is the Briton 8 at 3938 Dale Mabry Highway. It was built in 1956 as a single-screen movie theater with 2,200 seats. Back in its early days, the Briton was an important place. Some local movie premieres were held there, including one that was attended by Elvis Presley, according to John Petry, one of the managers. In 1973, it was "modernized" to have three smaller auditoriums, and it was remodeled again in 1992. The space that once held one screen now has eight, and it is still in operation. There is no documented history of tragedy at the theater, although there are rumors of a woman dying of a heart attack in the downstairs ladies' room. Despite that, ghostly sightings are a common occurrence.

The doors in the ladies' room will open and close, pipes will rattle and toilets will flush all by themselves. Voices are heard in empty hallways, and even full-bodied apparitions have been seen, especially on the upper floor, which was once the balcony of the original theater. Two different local paranormal groups have conducted investigations on the site. One psychic said that she sensed the presence of an older woman with jowls and long gray hair, as well as an older man named Jamie who worked at the theater in the 1960s. John Petry is interviewed on one of those investigations, and that interview appears on YouTube. In the video, he describes workers seeing people in the theater auditoriums, waiting for them to come out, and then, when the employee goes back in to check, there is no one there. John is not afraid to work at the theater, as all the spirits seem harmless, but he is definitely convinced that they are there.

The other haunted theater seems an unlikely place for a ghost. It is the Fun Lan Drive-In at 2302 East Hillsborough Avenue. Built in 1950, you can still go and see first-run films there from the comfort of your car. The ghost sighting takes place in the concession stand area. A very tall woman, over six feet, with long, dark hair walks right through the closed door. She purportedly stares at the floor and then vanishes. Perhaps she just doesn't like the movie.

and thumbed through the pages. The rose is nowhere to be found; it has simply vanished. Perhaps the long-dead vaudevillian still appreciates a gift of flowers after a performance.

A search of Tampa newspapers from the 1930s provides no evidence of the existence of Bessie Snavely, the lady in the red gown. It is possible that she is just a story concocted over the years by students. But if Bessie isn't real, what is the explanation for all the strange occurrences? And legend or not, who doesn't love a good ghost story?

Plant Hall

Across Kennedy Boulevard from the Falk Theatre stands a building that has come to symbolize the city of Tampa. Its tall Moorish towers, crowned by silvery, onion-shaped domes, can be seen on promotional and official literature.

The building is the legacy of a real-life "Connecticut Yankee" who believed that transportation systems would drive the future of the United States. His name was Henry Bradley Plant. Born in 1809, Henry grew up in the steamship era. As a young man, his grandmother offered to pay for him to be educated at Yale, but he turned down her offer. He wanted to learn the shipping business from the waterline up. He signed on as a deckhand on a steamship and worked his way to the top. He became an expert at moving cargo accurately and efficiently from place to place and quickly came to understand the value of rail transportation, expanding his business accordingly.

Henry married in 1842 and had two sons, but his wife, Ellen Elizabeth, was often ill. A doctor suggested that she might do better in a warmer climate. So they spent some time in Jacksonville, Florida. The weather did seem to have recuperative powers for Ellen, but upon their return to the North, she once again fell ill, dying in 1861.

Distraught, Henry threw himself into his work. Despite his Connecticut background, he formed the Southern Express Company, which provided rail service to the Confederacy during the Civil War. His trains carried not only packages but also messages and money. They also shipped home the bodies of the Confederate dead from the far-off battlefields. Many a Southern mother could actually bury her son in the family graveyard because of Henry B. Plant.

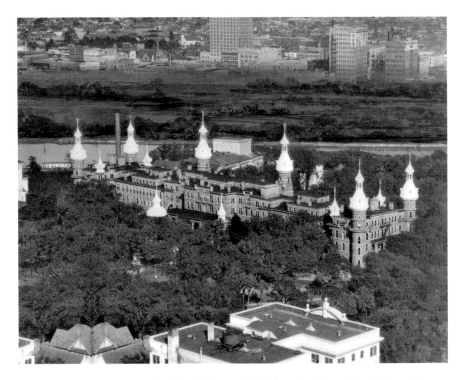

An aerial view of the Tampa Bay Hotel. *Courtesy of the Tampa-Hillsborough Public Library System.*

After the war, Henry used his connections to acquire the damaged and nearly destroyed railroads throughout the South, merging them into a new transportation system that made him a wealthy man. In 1883, phosphate, a mineral used to make fertilizer, was discovered in large amounts just southeast of Tampa. Henry Plant knew a moneymaking opportunity when he saw one, and he expanded his operation to include Tampa in 1884. But his rails did more than carry phosphate out of Florida. He also built two small hotels (both of which are long gone) and began to promote Tampa as a tourist destination. That way, his trains could carry passengers as well as freight.

The following year, in 1885, cigar manufacturing began in an area just outside of town known as Ybor City. The population of the area exploded. Between 1870 and 1890, the population went from 720 to 5,532, an astounding growth rate of 668 percent. Henry thought the time was right to build his masterpiece, and construction began on the beautiful Tampa Bay

Hotel. One might call it Florida's first theme park, for it was far more than just a hotel. Situated on 150 acres along the Hillsborough River, the hotel alone was a quarter of a mile long. A luxury resort with over five hundred rooms, it featured manicured European-style gardens leading down a graceful slope of lawn to the river. There was an amphitheater where band concerts were held, including one by famous composer and bandleader John Philip Sousa. There was a golf course, tennis courts, a bowling alley and a heated swimming pool, which was an unheard-of luxury for its day. Guests could also choose to go fishing, sailing, rowing, canoeing or bicycling. Even carriage rides, rickshaw rides and hunting were available.

The *New York Times* described the resort in 1891 as "brightly illuminated, filled with sumptuous decorations, thrilling music and graced with turrets, domes and minarets towering heavenward and glistening in the sun." It was the first building in Tampa with electricity, which came from its own generators. It also had the city's first elevators, one for passengers and one for their luggage. Its striking architecture was described as "Moorish Revival" by its designer, J.A. Word. And building it cost an exorbitant amount of money for the day, $2.5 million. An additional $500,000 was spent on the furnishings. This was not a place for the locals to stop by after work to have a beer. It was built specifically for the wealthy New England elite to laze away "the season," which lasted from December through April. They arrived in their private railroad cars attached to one of Henry Plant's trains and rented sumptuous suites of rooms and enjoyed the resort's amenities.

By the time the Tampa Bay Hotel was built, Henry had remarried. He and his second wife, Margaret, traveled extensively in Europe, selecting lavish decor and furnishing, not just for the Tampa Bay Hotel but also for the Bellview, Henry's Victorian-style hotel built on the Gulf Coast beaches near Clearwater in 1896.

Although all seemed well at the hotel, its five hundred rooms were never completely filled. The extravagant hotel was barely breaking even. The only exception came in the summer of 1898. During the Spanish-American War, Tampa was selected by the United States War Department as the point of embarkation for troops to Cuba, only 330 miles away. Thirty thousand troops filled every nook and cranny of Tampa, including the Tampa Bay Hotel. Of course, it was the officers and newspaper journalists who got to stay in the deluxe accommodations. In fact, the Spanish-American War is known as the "Front Porch War" because much of the planning was done on the vast front porch of the Tampa Bay Hotel. The officers reclined in comfort on the shady veranda, while the ordinary soldiers, in their heavy

wool uniforms, sweltered in hot and dusty tents. It was the only time in the history of the hotel that it was filled to capacity.

When Henry Plant died in 1899 at the age of eighty, he left behind a controversy. Shortly before his death, he changed his will, leaving the bulk of his $30 million fortune (a tremendous amount of money in 1899) to his four-year-old great-grandson. Henry's wife, Margaret, and his only surviving son, Morton, were obviously not pleased. Even though Henry had provided them with an annual income of $30,000 per year, a considerable sum for that day, they felt that they were entitled to the entire estate. They contested the will, and a New York court saw things their way. They were granted the full fortune to split between themselves. They had little interest in the running and maintenance of the grand resort on the banks of the Hillsborough, and the property began to fall into disrepair. In 1905, they sold the hotel to the City of Tampa for $125,000. It was closed as a hotel and used for community events, including Gasparilla banquets and the first Florida State Fair, which is still held in the Tampa Bay area to this day.

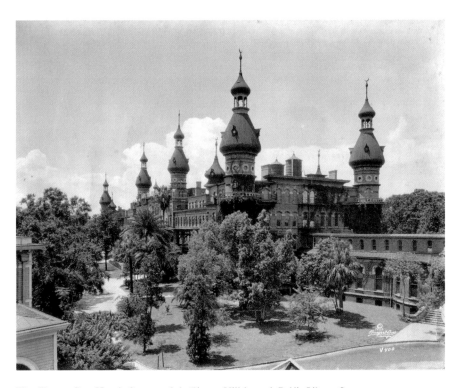

The Tampa Bay Hotel. *Courtesy of the Tampa-Hillsborough Public Library System.*

The building was closed for remodeling in 1930. When it reopened in 1933, it had been repurposed as the University of Tampa. Today, it is known as Plant Hall and houses classrooms, laboratories, public rooms, academic offices and administrative offices for the university. It is not a dormitory. No one sleeps here. And perhaps that is a very good thing, for spirits walk its long corridors both night and day. One ghost stays mainly in the section of the building nearest Kennedy Boulevard. This area is known as the Henry B. Plant Museum and is still decorated with the opulence of the early days. In these rooms, one can imagine oneself a part of those glory days of the Victorian era in Tampa. The museum is well worth a visit, but if you go, keep your eyes open for the figure of a portly gentleman wearing riding gear and sporting a pince-nez. You may just catch a glimpse of him out of the corner of your eye. This is the spirit of a man who was here for the Spanish-American War, but he later would become the twenty-sixth president of the United States. Theodore Roosevelt, affectionately known as "Teddy," was so intrigued and inspired by the Spanish-American War that he formed a group of volunteers called the Rough Riders, and he led them in a famous charge up San Juan Hill in Cuba in 1898. Prior to going to Cuba, he stayed at the Tampa Bay Hotel with his second wife, Edith. They must have enjoyed their stay, for the couple continues to be seen in the area of the museum, even though Teddy died in 1919 and Edith in 1948.

Another sighting occurs in the old passenger elevator. Of course, back when the hotel was built, elevators were not self-serviced—you didn't just hop in and press a button. In those days, the elevator was operated by a lever, and it required a certain amount of skill to make sure the elevator was level with the floor on which it stopped. After all, Henry didn't want his wealthy guests to trip on an uneven threshold. The operators who were hired to do this important job were always men. They dressed in a uniform that included a red bow tie. Currently, the old passenger elevator is not in use, but it sits on the first floor with its doors open. The car of the elevator is quite large and beautifully finished with wood paneling and a red carpet. Students have said that as they hurry past the open doors of the elevator, they have caught a glimpse of a man wearing a red bow tie, seated on a stool next to the elevator controls while reading a newspaper. When they take a second look, the man has vanished; there is not even a stool sitting there. Could this be an echo from the past? Is one of the operators simply passing the time while waiting for a request to take a guest to one of the upper floors?

Students also claim to have seen an old custodian pushing a cart of cleaning supplies. He is most frequently seen in the long corridor that leads

from the lobby to the music room. He is described as an African American wearing dusty boots and a straw hat. And his cart has a very squeaky wheel, making a distinctive, repetitive sound. In fact, the sound is often heard even when the apparition itself is not seen. One young female student, an early riser, would often leave her dorm and go over to Plant Hall to study during the early morning hours, as it was a quiet place for her to concentrate. One morning, as she entered the building and walked down the hallway looking for an empty classroom, she heard that distinctive squeak. She felt a chill come over her, and she felt very uncomfortable in the hallway. She quickly ducked into a classroom. She immediately felt better. She sat down at one of the desks to study, but a few moments later, she heard the door open and the sound of footsteps across the wooden floor. The desk next to her creaked as if someone was sitting down in it. She looked up to see who had joined her. The seat next to her—in fact, the entire room—was empty. Once again, she felt the chill she had experienced in the hallway. She quickly left the room in search of an unhaunted place to study.

Another young woman reported that while she was dating one of the security guards at Plant Hall, he invited her to accompany him on his rounds. They walked through the hallways, checking office doors and locking them. Just after he had locked one of the doors, she clearly heard a click from the lockset, as if the door had unlocked itself. When she tried the door, sure enough, it opened easily. She called out to her boyfriend and explained what had happened. He seemed very unconcerned. "It happens all the time," he said. "About half the doors here unlock all by themselves. Our orders are to just lock the doors and then move on. We'd be here all night if we had to go back to lock all the doors that refuse to stay locked."

According to the *Minaret*, the University of Tampa news source, on another occasion, a different security guard felt resistance on the doorknob he was attempting to secure. A few moments later, an unseen hand grabbed his flashlight from his grasp and threw it across the hall.

But not all ghosts are from the hotel days. August Ingley was a musician and respected professor at the University of Tampa in the 1930s and even composed the music for UT's alma mater. On February 2, 1938, he was giving a tour of the campus. While up in one of the minaret towers, he had a heart attack and died on the spot. The February 4, 1938 edition of the *Miami News* reported that a basketball game between Stetson College and the University of Tampa had been canceled out of respect for the late professor. His spirit is said to haunt the tower where he died. Those who go into the tower report cold spots and a strange feeling of being watched.

There is also a legend of Tim and Jerry, two fraternity brothers. The story holds that after leaving UT, both brothers died young, within a few years of each other. Their spirits returned to the school to be together and watch over new students. But the spirit most often encountered is known as the "brown man," and most believe that this is the spirit of Henry B. Plant himself. The apparition is dressed in a brown three-piece suit and a shirt with a high, starched color. He appears to be older, in his late seventies, with gray hair and an impressive gray mustache. He appears to be out of place and somewhat confused. His skin is pale, almost white. He has bright red lips and piercing bright blue eyes. Sometimes those eyes glow red, with an almost laser-like intensity. One student tells of a night when she had just completed a term paper. She was late with the assignment, having finished at about two o'clock in the morning on the day after the paper was due. Her professor's office was in Plant Hall. She thought if she could slip into Plant Hall and slide her paper under her professor's door, he might think she had turned it in on the evening of the day it was due and give her full credit. Upon arriving at Plant Hall, she was concerned about getting into the old building, but to her surprise, she easily found an unlocked door. She crept up the dimly lit stairway to the second floor, found her professor's office and slid the envelope containing her term paper under his door. As she straightened up, she felt as if she was being watched. She glanced down the hallway and saw the figure of a man in a brown suit about fifty feet away. She said that she never saw the image move its legs in any way but that it was suddenly ten feet closer. And then again, without any discernible effort, the man was another ten feet closer. Then it was staring her right in the face, its blue eyes glowing red. She screamed, and the image disappeared. She never went into Plant Hall after dark again.

On another occasion, a girl had accompanied her father, who worked in maintenance at Plant Hall, to the building in the early morning. It was about 5:30 a.m., and she was exploring a little on her own. As she was standing on the second-floor landing of the huge main staircase, she happened to glance upward. On the third-floor landing, she saw a man, in profile, wearing a brown suit. She thought he looked lost, so she called up to ask him if he needed any help. As the figure turned to face her, the eyes glowed red. Frightened, the girl ran off and found her father. Together, they returned to the staircase, but there was no one to be seen.

On the second floor, the image of the "brown man" has been seen reflected in mirrors and old window glass. He has also been seen, by students

and professors alike, sitting calmly on the central staircase, drinking from an old-fashioned teacup.

If this is indeed the ghost of Henry Plant, why does he haunt here? He did not die in the hotel, but it is definitely an important part of his legacy. Is his spirit restless because his last wishes were not honored and his will was broken by his widow and son? What exactly was going on in the Plant family in 1899 that created this struggle for money and power? And as he sits on the stairs, drinking his tea, does he look down at the beautiful old lobby, which has been transformed into a student gathering place? There are posters and banners everywhere. Signs are taped on the stately marble columns. Students hurry by with backpacks slung over their shoulders. It is controlled chaos. Is the ghost of Henry Plant just wondering, "What has happened to the quality of guests in my grand hotel?"

Not far away from Plant Hall, just upstream on the Hillsborough River, is an old railroad bridge. No longer in use by trains, the span is permanently elevated in the open position, at about a forty-five-degree angle, to allow the passage of boats beneath. Just at sunrise, a phantom train steams along the tracks. It approaches the gap created by the elevated span, goes right over the empty space and then disappears. Those who have seen it say it doesn't happen every morning and that you have to look quite carefully to see the misty image of an engine and freight cars in the early morning light. Paranormal experts describe this kind of activity as a residual haunting. There is no intelligent or interactive entity at work here. It is simply an echo of the past that repeats itself over and over.

PART V
AROUND THE BAY

THE SUNSHINE SKYWAY BRIDGE

Bridges are notoriously haunted places. Old folklore suggests that a spirit cannot cross moving water, that it needs a solid object—like a bridge—to get to the other side. Of course, the Tampa Bay area has no shortage of bridges. But the most infamous is the span that crosses the very mouth of the bay. It connects the tip of Pinellas County with Manatee County to the south and also passes over Hillsborough County waters.

In pioneer days and well into the twentieth century, a ferry operated at this spot. The first bridge was built in 1954, with a second span added in 1971 to make it four lanes, with each span carrying two lanes of one-way traffic. The bridge was an engineering challenge for its builders, as it had to be high enough for freighters to pass underneath, carrying goods into and out of Tampa Bay. And from the time it was opened to traffic, it became an attraction for those despairing souls who wanted to take their own lives. There were fifty-one cases of suicide by jumping from the bridge between 1954 and 1987. Of course, there may have been more, if the jumper was unobserved and the body was never found.

The year 1980 was a very bad one for the Sunshine Skyway Bridge. On January 28, the U.S. Coast Guard cutter *Blackthorn* had just completed an overhaul at the Gulf Tampa Drydock Company. It was headed back out to sea and about three-quarters of a mile from the Sunshine Skyway when it was passed by the Russian passenger vessel *Kazakhstan*. Unfortunately, the

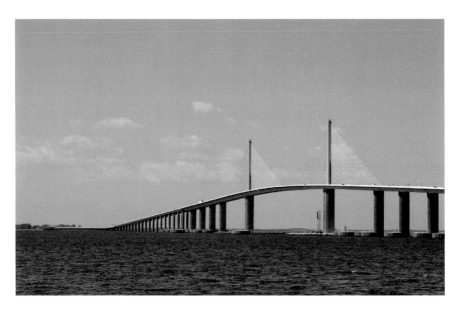

The Sunshine Skyway Bridge. *Author's collection.*

captain of the *Blackthorn*, Lieutenant Commander George Sepel, had just left the bridge, leaving an inexperienced officer, Ensign John Ryan, at the helm. Partially blinded by the lights from the passenger vessel, Ensign Ryan maneuvered the *Blackthorn* into the middle of the channel, not seeing that a freighter, the *Capricorn*, was heading straight for them. Despite both ships taking evasion action, they collided nearly head-on. As bad as that seems, damage would have been minimal except for the fact that the *Capricorn*'s anchors were set and in position for docking on the front of the ship. One of the anchors became embedded in the hull of the *Blackthorn*. As the ships moved away from each other, the *Capricorn*'s anchor chain pulled taut and caused the smaller *Blackthorn* to capsize. Twenty-seven crew members escaped, but twenty-three were trapped below deck as the ship turned over. All twenty-three lost their lives. The *Blackthorn* sank within ten minutes. It was the worst peacetime disaster in U.S. Coast Guard history.

One of the men who died was a true hero. Seaman William "Billy" Flores was only eighteen and had been out of boot camp for less than a year. He could have saved himself, but he chose to remain on board as the ship was floundering. He made his way to the life-jacket locker and began throwing flotation devices to his crew mates who were struggling in the water. He tied the door to the locker open with his own belt so that life preservers would

float to the surface, even as the boat was sinking. He went down with the ship. Although his heroism was not recognized at first, he was awarded the U.S. Coast Guard Medal in 2000, twenty years after the sinking.

The hull of the *Blackthorn* was raised three weeks after the accident. Deemed damaged beyond repair, it was towed twenty miles offshore and now rests at a depth of eighty feet. The ship now serves as an artificial reef and is a popular spot for divers.

Only a few months later, on May 9, 1980, the Sunshine Skyway was the scene of another disaster. This proved fatal for the bridge itself. During one of Tampa's famous thunderstorms, a 590-foot-long freighter, the *Summit Venture*, was negotiating the narrow channel approaching the Sunshine Skyway Bridge. At approximately 7:30 a.m., the ship's radar failed, and it slammed into one of the support piers of the southbound span. As a result, 1,200 feet of bridge decking fell into Tampa Bay. Eight vehicles simply drove off into nothing, falling 150 feet to the water. Most tragically of all, one of the vehicles was a Greyhound Bus, bound for Miami with twenty-five passengers. Thirty-five people died that rainy morning, but one man did survive. Wesley MacIntire was alone in his pickup truck crossing the bridge when the span fell. But his vehicle hit the deck of the *Summit Venture* before sliding off into the water, enabling him to escape. Even to his dying day, in 1989, MacIntire suffered from survivor's guilt, always sobered by the fact that he lived through the fall when so many others died.

The death toll might have been much higher, but a man named Richard Hornbuckle managed to bring his Buick Skylark to a stop on a span that had not yet fallen but was teetering on the brink. Heroically, he crawled up the slanting span and stopped other vehicles from driving into the abyss.

When Al Ford, a retired Tampa police officer, heard about the accident, he flew his Piper Colt, *Tillie the Toiler*, over the scene. He reported that he could see the eerie sight of car headlights still glowing underneath the murky waters of the channel.

As strange as it sounds, the *Summit Venture* continued in service in the Tampa Bay area for the next thirteen years. It was then sold several times and put to various uses before sinking (with no loss of life) off the coast of Vietnam in 2010. John Lerro, the captain of the ship on that fateful day in 1980, was absolved of all blame in an official inquiry.

The northbound span of the bridge was not damaged and continued to serve, with just one lane of traffic in each direction, while a new Sunshine Skyway was being constructed. Many people avoided the area, instead finding other ways to cross Tampa Bay.

The new bridge is a thing of beauty. Now known as the Bob Graham Sunshine Skyway Bridge, the central span of this 21,877-foot-long structure is held up by a series of cables that look like two huge, golden sails rising above the channel. It is considerably higher than the old bridge, and the construction is supposed to be immune from the kind of damage caused by the *Summit Venture* over thirty years ago. But there are many in the area who are still afraid to drive across the bridge. One local resident says that she holds her breath until she reaches the top, at which point she can clearly see that all the bridge decking remains in place.

But those who are suicidal are still drawn to the bridge. Since it was opened to traffic in 1987, there have been over two hundred documented deaths caused by jumping off the bridge. It is also estimated that over thirty people have attempted to kill themselves but somehow survived the fall. One of the survivors, a dog named Shasta, was either carried over the edge or followed his master, who jumped to his death. And one person committed suicide by hanging himself from the bridge.

With so much death and sorrow connected to one bridge, it's only natural that ghost stories would follow. The most common of those stories is that of the blonde hitchhiker. Some believe this is an urban legend, but it has been reported so many times by so many people that it seems credible. Travelers over the bridge report that they have stopped to pick up a young woman who is hitchhiking along the approach. This always occurs on a stormy or foggy night, and the girl is said to look so pitiful that people just feel the need to help her by giving her a ride. She is described as wearing jeans and a white T-shirt. Sometimes, she is also described as wearing a hooded sweatshirt or being dripping wet. After climbing into the back seat, she seems normal and talkative as the car drives up the approach and onto the bridge itself. But as the summit of the bridge approaches, she gets quieter and quieter. At the top, she becomes agitated and nervous. Some have reported that she begins to sob. Others have said that she asks strange questions, such as, "Will Jesus forgive me?" or "Are you ready to die and meet Jesus?" When those in the front seat turn around in response, the young woman has vanished; the back seat of the car is empty. Is this the ghost of a suicidal woman who jumped to her death from the top of the bridge? If so, she died long ago, for this apparition has been seen from the earliest days of the old bridge. Or perhaps there is more than one ghostly presence looking for a ride. Often, travelers across the Sunshine Skyway will call 911 to report someone about to jump. But when emergency personnel arrive, there is no one there.

Most of the other stories seem to be related to the *Summit Venture* accident, and they center on the remains of the approaches to the old bridge that have been preserved as fishing piers. There have been reports of the sound of screeching tires, car horns and tearing metal. Some even describe a descending scream that ends with a splashing sound.

The most disturbing of all is the report that fishermen on the pier in the early morning hours have heard the sound of an approaching vehicle. When they look up, they see a pair of headlights bearing down on them. As they jump back, a phantom vision of a Greyhound Bus appears and drives right past them. They can feel the wind and smell the diesel exhaust from its passing. The driver of the bus is staring straight ahead with a white-knuckled grip on the steering wheel. All the passengers are staring straight ahead as well. But at the very back of the bus, an elderly lady sits. She looks directly at the fishermen, smiles and gives them a cheery wave before the apparition disappears into the early morning mist.

Supposedly, after the crashed bus was raised back in 1980, the Greyhound Bus Company salvaged what it could in terms of parts for use in other buses in South Florida. However, a curse seemed to follow those parts around. Buses with those parts have stopped running for no apparent reason, and some have even burst into flames. Eventually, the salvaged parts caused so much trouble that they were all removed and destroyed.

The Travel Channel has named the Sunshine Skyway Bridge as number three in its list of the top ten bridges in the world (behind only the Golden Gate Bridge in San Francisco and the Akashi Kaikyo Bridge in Japan). The channel extols its beauty and engineering, which would enable it to withstand an impact from a ship twice the size of the *Titanic*. But perhaps what make it one of the greatest bridges in the world are the restless spirits that cross over it.

The Ringling Ghosts

Not far south of Tampa Bay sits the town of Sarasota, with a current population of just over fifty-two thousand. It is justly famous for the white-sand beaches of its barrier islands. But it is also famous for its connection with John and Mabel Ringling.

Born in 1866 in Iowa, John Ringling was part of a large family of seven boys and one girl. John and four of his brothers joined together to form a circus troupe, the famous Ringling Brothers Circus. John began performing

at the age of sixteen. Starting off as a song-and-dance man, he worked his way up to become manager of the routes the show traveled. His strict attention to detail and his knowledge of the local towns and all the roads and highways were a big part of the success the Ringling Brothers enjoyed. In 1890, still a young man, John saw that the future of traveling circuses would be on the rails. He persuaded his brothers to make the change to trains. Soon, Ringling Brothers was being transported around the United States in nearly one hundred specially designed railroad cars.

They say that opposites attract, and flamboyant, confident John found himself attracted to a shy and quiet girl named Mabel Burton. By all accounts, she was a strikingly beautiful woman. She and John were married in 1905.

In 1907, Ringling Brothers acquired the Barnum and Bailey Circus, transforming into the most dominant force in American circuses. The circus still exists to this day, touring the country. John would have been proud of the way it now uses modern tools like the Internet to keep itself in the public eye.

John made a fortune with the circus, and he invested wisely in railroads, oil wells and other businesses. In the 1920s, he became interested in land in Florida. He also began acquiring works of fine art. Mabel helped him in the latter endeavor. She had an excellent eye for great art, and she and John would often go to auctions, willing to pay more than a piece was worth if they really wanted to own it. They also traveled extensively in Europe, gathering up fine art as they scouted for new acts for the circus.

In 1924, the couple began construction on a mansion in Sarasota. The influence of their European travels is evident in the architecture of the house, as well as in its name. Ca'd'Zan translates as "House of John" in the Venetian dialect of Italian. The style of the home is Venetian Gothic. It was completed at a cost of $1.5 million in time for the family to celebrate Christmas in their new home in 1925. To put this into perspective, the huge Don Cesar Hotel in St. Pete Beach, just a few miles away, was built three years later, and it cost $1.5 million for the entire hotel! John and Mabel had other homes in New York City and Alpine, New Jersey, but Ca'd'Zan seemed to be their favorite. The home is enormous. Its thirty-six thousand square feet includes forty-one rooms and fifteen bathrooms. It has a full basement, which is unusual in Florida. It is five stories tall and has an eighty-one-foot-tall tower with an open-air overlook.

Although the couple had no children, they were devoted to each other and enjoyed their life together and the love of art that they shared. Mabel died from pneumonia in 1929. She was only fifty-four. John's health began to decline after Mabel's death, and he passed away in 1936, still the number-one showman in the United States, the undisputed "King of the Big Top."

Today, Ca'd'Zan is open to the public for tours on a daily basis. You can also tour the Ringling Museum of Art, the Circus Museum and the beautiful rose garden that Mabel started in 1913 and dearly loved. You could set aside an entire day and still not see everything.

And many believe that you can still meet Mabel when you tour her palatial home and gardens. Her lithe figure is most frequently seen on the terrace of the house itself. Unexplained cold spots are also encountered in the house, and visitors have felt a strong presence even when no one else is in the room. Mabel's shadow appears in the rose garden and on the balconies of the home.

Why would this gentle lady, quiet and shy, come back to haunt? Perhaps it is because this is where she was happiest in life and where she is happy still—in her beautiful home, surrounded by the flowers and art that she loved so much.

And John? Some believe he is there, too. But he is spotted far less frequently than Mabel. It is a stunning reversal of roles. The flamboyant showman lurks in the shadows, while his shy wife comes out to greet her guests.

Reportedly, there is a ghost at the Circus Museum as well, but it is not a member of the Ringling family. It is believed to be the ghost of the official Ringling Circus priest, an important and well-loved member of the troupe. Perhaps he remains to provide "spiritual" guidance to his flock.

There is another ghost associated with the Ringling properties, but she has no direct connection to either the circus or the family. Her name is Mary, and she haunts the Ringling School of Art and Design, which was originally the Bay Haven Hotel.

The Bay Haven was built in 1925 in the Spanish Mission Revival style. It was an elegant refuge for many who came to the area for either business or pleasure. However, as the Great Depression loomed on the horizon, reservations fell to a trickle, and a less reputable type of guest began to frequent the hotel, as prostitutes and gamblers became the norm.

By 1931, John Ringling had founded what was then called the School of Fine and Applied Art of the John and Mable Ringling Art Museum—quite a mouthful. Sensibly, rather than constructing new buildings, they looked around for existing structures that could be used. Among the buildings they purchased in the early '30s was the Bay Haven Hotel.

Today, the school has a much shorter name and is a private four-year college. Tuition for the 2013–14 academic year is over $52,000 if you include room and board. The school has an excellent reputation in all of the fine arts and offers several different areas of study. There are about one thousand students, and the campus covers thirty-five acres. What was once the Bay Haven Hotel is now known as the Keating Center. It provides

student housing, described as single rooms for first-year students. The rooms measure about ten feet by ten feet, so the accommodations are less than palatial, although they appear comfortable enough.

But some of those "single" rooms might actually come with a roommate.

According to legend, during the days when the Bay Haven Hotel was suffering through hard times, one of its residents was a young prostitute named Mary. The legend holds that Mary took her own life by taking a fabric cord from the curtains and hanging herself in the stairwell. She was only eighteen or nineteen years old. Was she unable to cope with being a "fallen woman" any longer? Or was something more sinister at work? Some say she suffered from unrequited love from one of her customers, who was a married man. Some versions of the legend contend that the unfortunate young woman had been raped. And some versions claim murder instead of suicide.

However she came to die, she refuses to leave the premises. Those who have seen Mary say she is neither frightening nor menacing. She is simply a sad and lonely presence. Most sightings are quite clear. A woman by the name of Elizabeth Heath says that when she was a first-year student back in 1985, she saw Mary so well that to this day she remembers what she looked like. A cleaning woman named Sandra was working in a bathroom in Keating Center when a woman appeared, although the door had not opened. The specter put her fingers to her lips and said, "Shhh," as if asking Sandra not to tell her secret. Then she vanished.

The Travel Channel featured Mary's story on an October 2004 special called *Haunted Campuses*. Christina Siciliano, one of the students interviewed, said strange things would happen in her room. The television would turn on and off by itself, and items such as earrings and keys would be moved from the place where she had left them. The door would also lock or unlock by itself. At first, she didn't think much of it. She thought perhaps someone was playing a prank to scare her. But then, one evening, she saw a woman in a black nightgown float

Although no one knows what "Mary" looked like, this picture shows a typical woman of that era. *Courtesy of the Gulfport Florida Historical Society.*

through a door into a room at the end of the hallway. When she checked, the room was just a closet, and there was no one inside. On another occasion, she was roused from a deep sleep by a flash of light and the sound of a vase crashing to the floor. And there was no vase in the room. After that, she made it a point to say, "Goodnight, Mary" before she turned out the light. That seemed to help things until about six weeks before the end of the school year, when she was awakened by a scratching noise. When she opened her eyes, a pale face was floating just inches from her own. Terrified, she told the apparition to go back to sleep. That seemed to work. The face disappeared, and she never saw it again.

Over the years, students have reported seeing the misty figure of a woman in her teens or early twenties gazing out of second-floor windows. She wears a cream-colored dress with ruffles and has short, dark hair. Much more disturbing are reports of a skeletal figure in tattered clothing with rotting hair and flesh and two dark eyes staring from inside the skull. Or even worse, the image of a pair of feet, not connected to anything, simply dangling in the stairwell where Mary hanged herself and the scent of a woman's perfume, like the smell of violets, lingering in the air.

One male student complained (or bragged?) that Mary's spirit seemed to have formed an attraction to him. He would smell her perfume and hear her giggling in the hallway outside his room in the middle of the night. He would return to his room after class to find the impression of a female figure in the bed he had carefully made before leaving in the morning.

So, if you have a chance to visit Sarasota, be sure to look for the spirits of two very different women—Mabel Ringling at Ca'd'Zan and sad Mary at the School of Art and Design—whose spirits linger in this little town near Tampa Bay.

Howard W. Blake High School

This high school, originally open only to African American students, was founded in 1956 in a different building than the one it occupies today. It is named for Howard W. Blake, a Tampa native who made it his mission in life to help young people realize their full potential through education. When Tampa schools were integrated in the 1960s, Blake was strictly a seventh-grade center until 1997, when it opened in its new building and became a magnet school for the visual, communication, journalism and performing arts, including

theater, music and dance. Those programs often win awards and honors for excellence, and the school carries an "A" rating from the State of Florida.

Apparently, it also carries a few spirits.

The place where the building now stands was once the site of the Clara Frye Negro Hospital. Clara was a trained nurse, born in Albany, New York, in 1872. She was the daughter of an African American man from the South and a white woman from England. She moved to Tampa in 1908. In those days, blacks and whites were not treated in the same facilities. When Clara found out from a local physician that an African American patient would die if he did not have surgery and that there was no place willing to allow the operation, she offered her own home for the surgery. The patient survived. She eventually, with some help from the City of Tampa, opened her hospital in 1923. She never turned anyone away from treatment, even if they were unable to pay. She had a deep and abiding religious faith that moved her to help others. Clara died in 1936 at the age of sixty-four. This great woman was all but destitute after having poured all her energy and money into caring for the community. Her hospital was closed in 1967 and torn down, but by then, Tampa General Hospital was fully integrated.

Students at Blake are convinced that spirits of some of the people who died in Clara Frye Hospital haunt the halls of their building. They believe that "B Building" was built over the site of the hospital's morgue. A drastic drop in temperature can be felt when walking down the corridors, even when the air conditioning is not working. The smell of antiseptics and other hospital smells are also prevalent, even when there is no possible source for the odor. Cold spots in the auditorium are attributed to the death of a teacher who died of a heart attack during a pep rally. And sitting at the back tables in the library will cause hair to stand on end and chills to run up the spine. But the most haunted area at Blake seems to be the theater. Strange lights are seen in the wings, and something seems to go wrong in every performance. Of course, that could just be the nature of live theater. But the students definitely believe.

Of course, all this gives new meaning to the phrase "school spirit."

The Grey Lady

In the Port of Tampa harbor, at 705 Channelside Drive, sits the SS *American Victory*. Known as the "Grey Lady," she was built in 1944 in just fifty-five hours due to the needs in the Pacific during World War II. She is 455 feet long, has a 62-foot beam and can cruise at a speed of seventeen knots. She

served as a cargo ship until the end of the war, at which point she was put to use carrying materials to Europe under the Marshall Plan. Scheduled to be scrapped in 1999, she was saved because she was selected to become a floating museum in Tampa. The *American Victory* is one of only four fully operational World War II ships. The full ship can be toured, and she is still taken out to sea for Living History Day Cruises.

During her years of service, one of her duties was to bring back the bodies of fallen soldiers. She carried over one hundred such bodies in coffins in a refrigerated room, which can be viewed today. Also, three crew members died due to accidents loading heavy equipment. These two things are believed to be the source of the hauntings on the ship.

In October of each year, the *American Victory* Museum offers Grey Lady Ghost Tours. The tours are done as a cooperative effort between the maritime museum and a group called Tampa Ghost Watchers. There is a presentation on the history of the ship, and there are docents on hand to answer questions. The guests are then given time to wander about the ship using paranormal investigative equipment. People who take these tours have experienced cold spots and feelings of unease. There have been very high readings that indicate that a ghost is present, and photographs have shown orbs and strange lights. This is a sad reminder of the loss of life experienced during World War II, but it is also a fascinating glimpse into an important part of our nation's maritime history.

The Sulphur Springs Water Tower

The history behind many ghost stories can be well documented, but some other stories fall more into the realm of urban legend. The story of the Sulphur Springs Water Tower tends to fall into the latter category. But it is such a well-known legend that no book on haunted Tampa would be complete without it.

There are some things we do know as fact. The tower was built in 1927 by Josiah Richardson as part of a community called Sulphur Springs, which at that time was totally separate from Tampa. It was designed to be both a livable community and a tourist attraction. There was a shopping mall, a bathhouse gazebo, a water slide and an alligator exhibit. Richardson liked to do things first class; nothing on the cheap would do for him. So when he realized he would need a water system for his new development, he went all out. There is no doubt that the structure of his water tower is beautiful. It was designed to look like a lighthouse or perhaps the turret of a medieval castle. It is 214 feet tall, and its white surface gleams like silver in the Florida sun.

At first, things went very well. The image of the tower was featured on thousands of postcards. But hard times were ahead for Sulphur Springs. A flood in 1933 took its toll on the development. Then came the Depression, and then World War II. Richardson went bankrupt, and Tampa annexed Sulphur Springs in 1953. In the 1960s, the I-275 expressway cut what was left of the community in half. The shopping mall was flattened and turned into a parking lot. But the tower remained. It is still standing, although not accessible to the public. It is owned by the City of Tampa and is now illuminated at night. From there, things get a little murky, and fact gets confused with legend.

In 1951, the Tower Drive-In Theatre was built nearby. Carl Harris, a young child at the time, remembers going to the drive-in movies with his parents. When a movie didn't interest him, Carl would stare at the old water tower, which looked ghostly in the darkness. He said he remembers the hair standing up on the back of his neck and seeing balls of light and the vague shapes of faces in the windows. Then, one day, he noticed that the windows on the lower levels were being boarded up. His father told him that people had been going into the old tower and climbing the old steps, which were no longer safe, and falling and getting hurt. The upper windows remained open to the elements.

One often-repeated story is that a young girl was pulled under the water by "something" while swimming near the old gazebo bathhouse. Supposedly, witnesses reported that she was pulled under, thrown up in the air and then pulled down again. Her spirit is said to haunt the gazebo itself. There is no documentation of this incident.

Another tale that has been told over and over is that Josiah Richardson was a Satanist and that his house was built with a basement to accommodate occult rituals. It has also been claimed that the foundation of his house was made of stones he had deliberately selected because they were shaped like human skulls and that the reason his house, the gazebo and the water tower form the points of a triangle was that the shape had Satanic significance. Again, there is no evidence that this is true. In fact, many who knew Richardson have tried to debunk this particular myth.

A third story is that the water tower was built on the site of a former watchtower from the earliest days when pirates plied the waters of Tampa Bay. Its location was perfect because the bay could be observed without detection by those being watched. Legend suggests that the ghost of a pirate who was caught and hanged because he was seen from the watchtower still roams the grounds around the Sulphur Springs tower.

What is truth and what is fiction? It is almost impossible to know. Perhaps it doesn't matter. After all, a good story remains a good story, even if it stretches the truth a bit.

Selected Bibliography

Books

Jones, Maxine Delores. *African Americans in Florida*. Sarasota, FL: Pineapple Press, 1993.

Kirkpatrick, Jennet. *Uncivil Disobedience: Studies in Violence and Democratic Politics*. Princeton, NJ: Princeton University Press, 2008.

Meharg, Phillip. *Jose Gaspar and Other Pirates*. N.p.: AuthorHouse, 2003.

Moseley, Julia Winifred, and Betty Powers Crislip, eds. *"Come to my Sunland": Letters of Julia Daniels Moseley from the Florida Frontier, 1882–1886*. Gainesville: University Press of Florida, 1998.

Otto, Steve. *Spirit of the Bay*. Tampa, FL: Community Media Corp., 2007.

Powell, Evanell Klintworth. *Tampa That Was: History and Chronology through 1946*. Boynton Beach, FL: Star Publishing Company Inc., 1973.

Rajtar, Steve. *A Guide to Historic Tampa*. Charleston, SC: The History Press, 2007.

Reeser, Tim. *Ghost Stories of Tampa, Florida*. N.p.: 1stSight Press, 2004.

Sitler, Nevin D., and Richard N. Sitler. *The Sunshine Skyway Bridge: Spanning Tampa Bay*. Charleston, SC: The History Press, 2013.

Wilbanks, William. *Forgotten Heroes: Police Officers Killed in Early Florida, 1840–1925*. Nashville, TN: Turner Publishing Company, 1998.

Websites

City of Tampa. www.tampagov.net

510 Metro Building website. www.metro510.com

Bibliography

Henry B. Plant Museum. www.plantmuseum.com
Ringling College of Art and Design. www.ringling.edu
Ringling Museum of Art. www.ringling.org
Tampa Police Department. www.tampagov.net/dept_police
University of Tampa. www.ut.edu
Worthpoint. www.worthpoint.com

Interviews

Deborah Birchler
Carl Harris
Lesa McCarty

Articles

Canning, Michael. "She Made Blacks' Care Her Cause." *St. Petersburg Times*, March 7, 2003.
Fafvorite, Merab-Michal. "The Ghosts of Ringling." *Bradenton Times*, October 20, 2012.
Florida Historical Society Quarterly. "The Lynching of Charles Owen." July 1984.
Klinkenberg, Jeff. "Tower of Terror." *St. Petersburg Times*, July 13, 2003.
Mormino, Gary. "Free Love and the Long-Haired Quack." *Journal of the Tampa Historical Society* 10 (1984).
Otto, Steve. "Old Sunshine Skyway Bridge Collapsed 30 Years Ago." *Tampa Tribune*, May 7, 2010.
Sarasota Herald Tribune. "Ghost Rumored to Haunt Ringling School." October 31, 2002.
Thalji, Jamal. "Dantae Morris Arrested in Slayings of Tampa Police Officers." *Tampa Bay Times*, July 2, 2010.

ABOUT THE AUTHOR

Deborah Frethem has always been fascinated by history and mystery. She found a way to combine these two things by researching, writing and telling ghost stories, especially those that illuminate the history of an area. Although originally from Minnesota, she moved to Florida ten years ago and began to learn about Tampa Bay, which has become her new love. She previously published *Ghost Stories of St. Petersburg, Clearwater and Pinellas County* with The History Press in 2007. She enjoys using words, both written and spoken, to paint pictures of the past.

*Visit us at
www.historypress.net*

This title is also available as an e-book